POSTCARD HISTORY SERIES

Lake Tahoe

ON THE COVER: Bathers enjoy Homewood Resort in this jovial shot, portraying the fun and festive attitude of generations of vacationers at Lake Tahoe. Many of the early homes and resorts featured breakwaters to provide for a calm swimming area. The water in Tahoe is very cold, staying at a constant 39 degrees Fahrenheit below 600 feet. Shallow areas along the shore can warm up to 68 degrees during summer months.

ON THE BACK COVER: A respite with a view, these hikers would have enjoyed panoramas of the lake from many spots along the trail. The card, dated August 20, 1917, reads: "Dear Laura, Was glad we didn't wait until next boat as it was dark too early as things were! Dusk caught us in a very bad place in road—almost lost our way! Had no auto trouble tho so that helped some. Love from Bates."

POSTCARD HISTORY SERIES

Lake Tahoe

Sara Larson and the North Lake Tahoe Historical Society

ARCADIA
PUBLISHING

Copyright © 2008 by Sara Larson and the North Lake Tahoe Historical Society
ISBN 978-0-7385-5849-3

Published by Arcadia Publishing
Charleston SC, Chicago IL, Portsmouth NH, San Francisco CA

Printed in the United States of America

Library of Congress Catalog Card Number: 2008921001

For all general information contact Arcadia Publishing at:
Telephone 843-853-2070
Fax 843-853-0044
E-mail sales@arcadiapublishing.com
For customer service and orders:
Toll-Free 1-888-313-2665

Visit us on the Internet at www.arcadiapublishing.com

CONTENTS

Acknowledgments 6

Introduction 7

1. The Trip to Tahoe 9

2. Tahoe City to Rubicon 15

3. Emerald Bay to Stateline 45

4. Glenbrook to Incline 75

5. Crystal Bay to Carnelian Bay 95

6. Lake of the Sky 113

Bibliography 127

ACKNOWLEDGMENTS

The North Lake Tahoe Historical Society was founded in 1969 to preserve and present our area history. The Gatekeeper's Museum opened in 1981. Thanks to the dedication of the board, volunteers, and staff who have maintained the collections over the years. Special thanks to local historians Carol Van Etten, Mark McLaughlin, Miriam Biro, Linda Cole, Bill and Barbara Craven, and NLTHS member Carol Jensen, who have inspired me to think I could attempt to write this! This book could not have been compiled without the postcards from our Jerry Johnson Collection within the museum and from the private collections of Don and Jeanne Davis and John Rauzy. The museum postcard collection is showcased in this book unless otherwise noted. Thanks to Frasher Fotos, Nevada Historical Society, and Sierra State Parks Foundation for the use of some of their images.

INTRODUCTION

The postcards in this book provide a glimpse into the early days at Lake Tahoe. While thousands of these cards were printed, this will be the first time many of the cards have been seen for decades.

This postcard history of Lake Tahoe contains many never-before-published images from three collections. From the late 1800s to recent years, these images provide a great deal of insight into Tahoe's past. The majority of the old buildings and resorts are long gone along with the lumbering operations, cattle grazing, and daily catches of dozens of fish.

Though the basin that cradles the lake has changed a great deal over time, the lake itself retains its impressive beauty. At 23 miles long and 13 miles wide, the lake now has approximately 14 miles of shoreline that are accessible to the public; for comparison, it is 72 miles around the lake by car. This trip around Lake Tahoe will follow the steamer route going counterclockwise

One

THE TRIP TO TAHOE

Tahoe was "discovered" by John C. Fremont on February 14, 1844. Soon after, the silver boom started in Virginia City and Lake Tahoe's forests were cut and hauled away to shore up the mines. Even as the lumber was being hauled away, the tourists began their summer migration to the beautiful lake known for its clear cool waters and the often photographed Emerald Bay. Getting to the lake was half the fun in the early days. The majority of visitors made their way from San Francisco and Sacramento. Before the automobile made its presence known at the lake, vacationers would come by train to Truckee, where they would board the narrow-gauge railway to Tahoe City. If heading past Tahoe City, passengers would board the steamer *Tahoe* or go by horseback to their final destination. The 13-mile train ride from Truckee was said to have taken up to four hours to complete. In the late 1800s and early 1900s, most visitors stayed at the lavish all-inclusive resorts, while a few really roughed it by camping along the shores. Visitors could also come from Placerville by stage. Imagine the ride down the very steep Highway 50 into what is now South Lake Tahoe—a hair-raising experience to be sure. On the Nevada side, the old Clear Creek Grade and Kingsbury Grade were two ways to access the lake. By wagon or horseback, travel could not have been easy. With the advent of automobiles, people could arrive at the lake on their own; thus, the era of building one's own cabin began. Townships began to spring up around the lake.

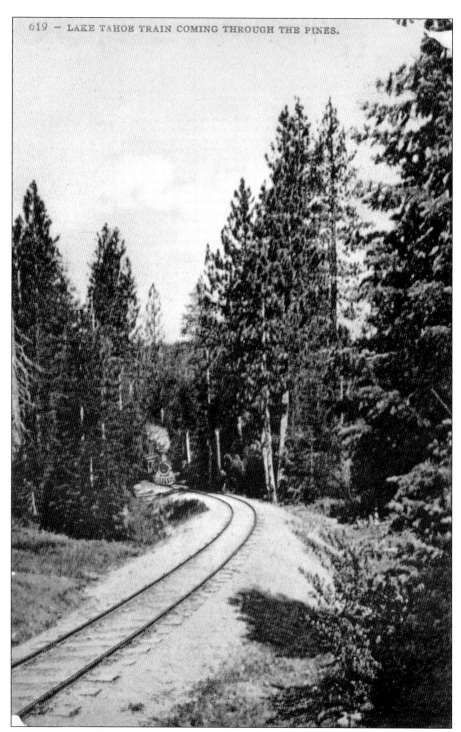

This card, postmarked in 1907, depicts a Lake Tahoe train coming through the pines. The card reads, "Dear Aunt Belle, I have been busy ever since I came home putting up fruit and vegetables, am feeling quite well how are you, the weather is finer here at present, Love to all. May."

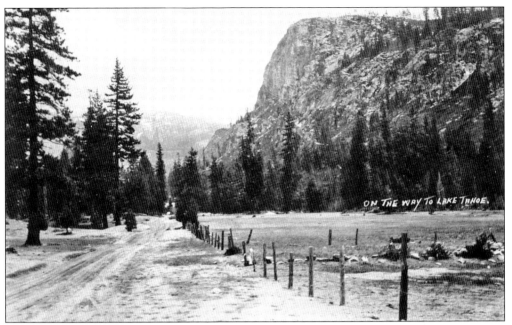

Here, on the way to Lake Tahoe, one can see the dirt road, which was flat in this section. What an adventure it was getting to the lake in the early days. Travelers could rest at an assortment of small hostelries along the way.

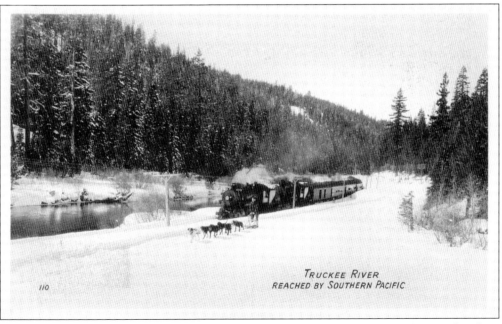

The railroad line along the Truckee River appears in this card at the spot where today there is a paved bike path. The Truckee River flows from Lake Tahoe to Pyramid Lake in Nevada. (Courtesy John Rauzy.)

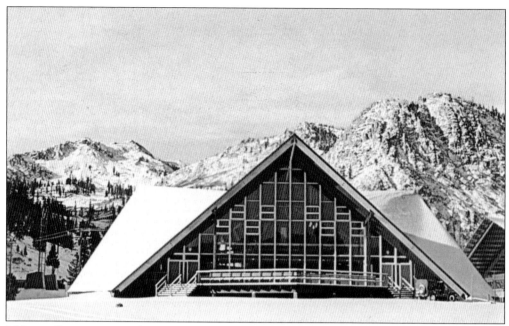

This card's caption reads, "World-famous Squaw Valley, California. Scene of the 1960 International Winter Olympic Games. Winter view of the colorful Olympic Ice Arena. This immense structure was designed to accommodate the figure skating and hockey competition, and provides shelter for viewing nearby events."

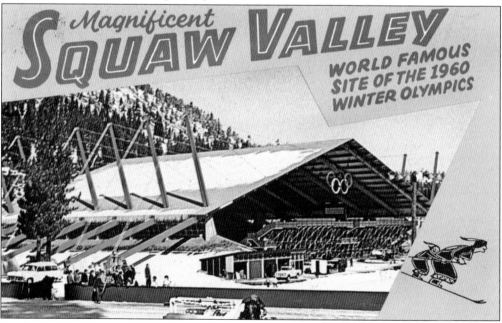

A winter view shows one of the enormous "warming huts" built to provide shelter for visitors and skiers. This card references Squaw Valley as a new California State Park. In 1863, a reddish ore was discovered near the mouth of Squaw Creek. News of a silver strike spread, and soon Knoxville sprang up and was quickly populated by those seeking their fortune. Knoxville and Claraville, which was upriver, disappeared shortly after the ore samples proved poor.

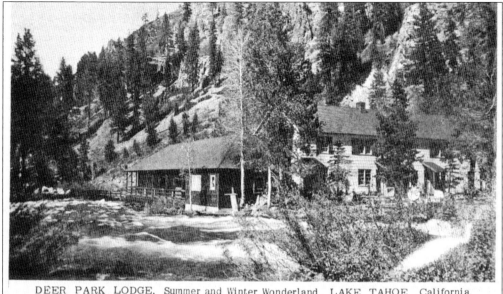

DEER PARK LODGE, Summer and Winter Wonderland, LAKE TAHOE, California

This postcard of Deer Park Lodge shows "Telephone 73-W" and touts furnished apartments, rooms, and cabins, as well as a private lake stocked with rainbow trout. The Truckee River runs through its entire 40 acres, and excellent skiing on lodge grounds is offered. This lodge was only one mile to famed Squaw Valley, home of the world's largest chairlift.

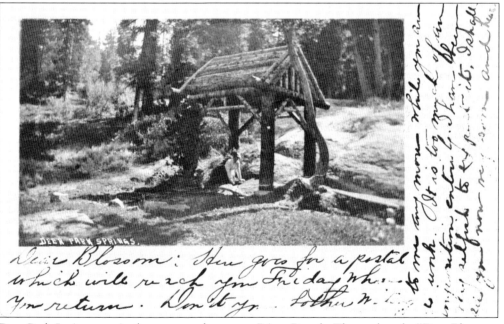

Deer Park Springs was in the area now known as River Ranch. The card reads, "Dear Blossom: Here goes for a postal which will reach you Friday when you return. Don't you bother writing to me anymore while you are at work. It is too much of an inspiration entirely. I have been very selfish to expect it. I shall see you now very soon and hear all about the wonderfulisms you have learned. I am very happy that the flowers reached you in good condition. Very much love to your mother and my Blossom from Mabel."

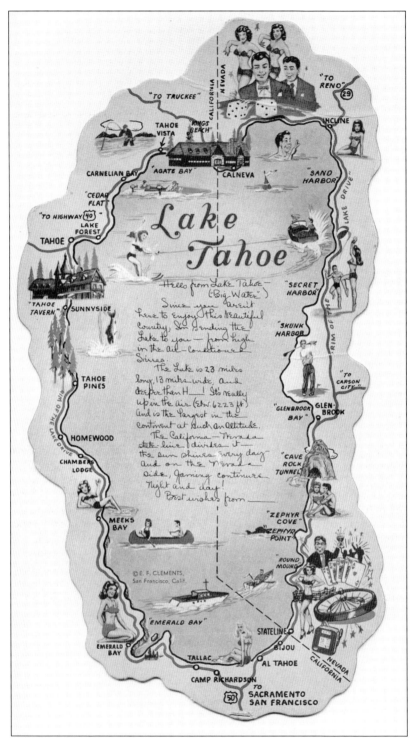

This cut-out postcard gives the highlights of places one could visit around the lake. The road around the lake is labeled Rim of the Lake Drive. There are plenty of bikini-clad ladies to help note the sunbathing beaches. (Courtesy John Rauzy.)

14

Two

TAHOE CITY TO RUBICON

Hotels and resorts sprang up around the lake as soon as Fremont reported his discovery. Tahoe City could be reached by train or wagon from Truckee. The famous Tahoe Tavern was located just one mile south of the Truckee River Outlet. The tavern, like many of the early resorts, had every amenity one could imagine, from a bowling alley to a movie theater to the dance hall. It was common in the early days for women to bring their children and stay for the summer while their husbands would come up to visit on the weekends. Early oral histories report coming to the lake from Placerville and Sacramento by horseback through the Rubicon and from the south shore, taking the horses across the mouth of Emerald Bay. Travel by early automobiles was not much easier as the roads were very rough and rutted. The hardy souls made it to the lake, where they could relax until their journey home began. From Tahoe City, this book will travel south around the lake and visit such notable spots as Homewood Resort, Chambers Landing, and Rubicon Springs.

Lake Tahoe, Nevada.

At the Truckee River Outlet, the large white building in this postcard was known as the Bicose. It was the home of Amy Cohn's summer curio shop. For over 10 years, Dat-so-la-lee, the most famous of the Washoe basket weavers, would come to Tahoe during the summer and weave baskets, many of which were sold through this store. Her patrons, Abe and Amy Cohn, also operated the Carson City Emporium Store.

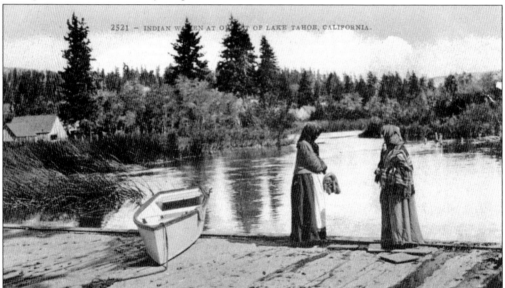

2521 — INDIAN WOMEN AT OUTLET OF LAKE TAHOE, CALIFORNIA.

This card, ostensibly of Native American women at the lake, is an advertisement for land. Imagine, as the card says, "Lake Tahoe Frontage. $10 per foot. Just think of it! Don't miss the chance to have a delightful mountain home; also a first class investment. Lakeside Park. Choice building lots, 50 ft. or more by 150 ft. deep, on easy terms. Title perfect. Will double in value before 1915. An ideal sandy bathing beach at your front door. Unsurpassed outlook toward the west, over the lake to the snow-covered mountain peaks, gorgeous sunsets and other features of Tahoe splendor."

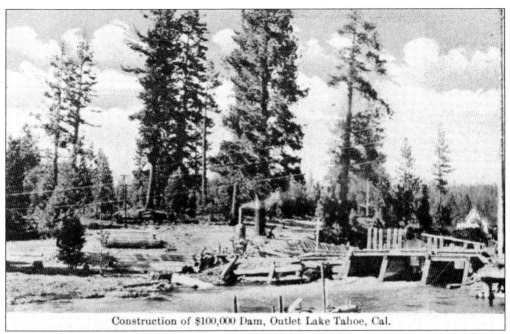

Construction of $100,000 Dam, Outlet Lake Tahoe, Cal.

Depicting the construction of the $100,000 dam at Outlet Lake Tahoe, the back of this card reads: "Photograph taken in Spring—1910 Looking NE. 1910–1913 "New" Truckee River Outlet replacing the "Remodeled" Col. Von Schmidt's Tahoe Outlet Dam." The lake was raised six feet in order to make the dam operable. Water rights are held by irrigation districts downstream. Tahoe holds over 39 trillion gallons. If completely drained, it could cover a flat area the size of California to a depth of 14 inches but would take over 700 years to refill.

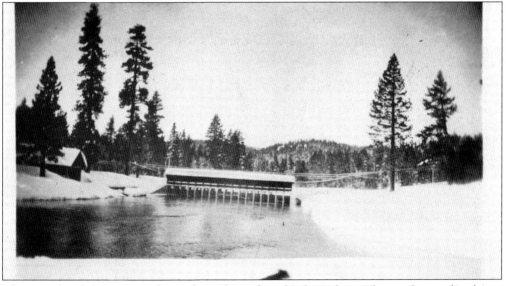

The completed dam is seen here, the only outlet of Lake Tahoe. The gatekeeper lived in a house on the left side and regulated the lake level. The note on the back describes being unable to take the boat out of the boathouse (seen on the left) since the water was too low. Sixty-three streams flow into Lake Tahoe, but only one, the Truckee River, flows out past Reno and into Pyramid Lake.

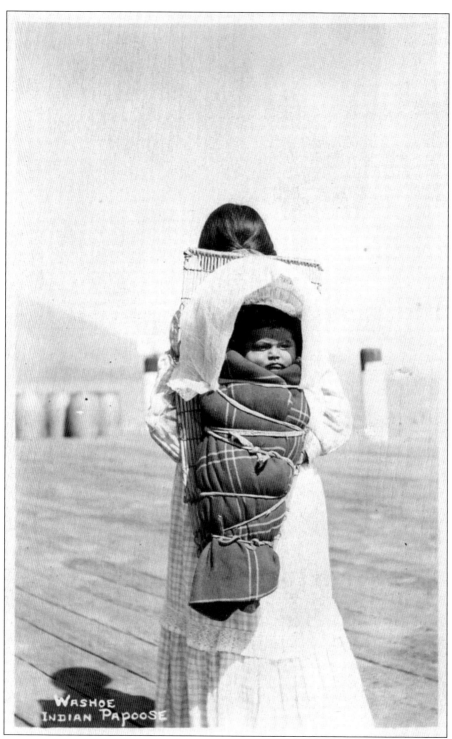

WASHOE
INDIAN PAPOOSE

Though it is mislabeled as an "Indian Papoose," this photograph shows a Washoe cradleboard or baby carrier in use. Fashioned out of peeled willow branches and the thread of willow bark, it held babies snugly secured and easily transported them.

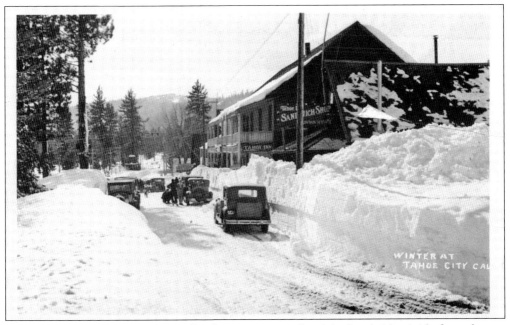

The Tahoe Inn Sandwich Shop and Tahoe Inn are on the right-hand side. Aside from the age of the automobiles in this photograph, the scene looks very familiar—the tall snow banks on either side of the street and folks next to their cars in the street fixing their chains.

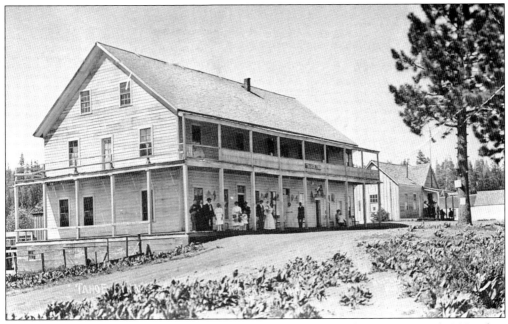

The Tahoe Inn was constructed about 1876. There were a series of owners up until 1930, when Carl "Pop" Bechdolt bought out his two partners. The inn, dance hall, original log cabin, and a handful of outbuildings burned down in 1934, reportedly because of a kitchen fire. The inn was managed by the Bechdolt family until its sale in 1974.

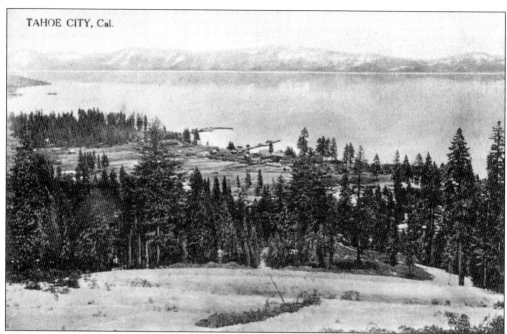

From up on the hillside can be seen the outstretched meadow and piers jutting out into the lake. Far off in the distance is the bare hillside where nearly all of the trees had been logged. (Courtesy of John Rauzy.)

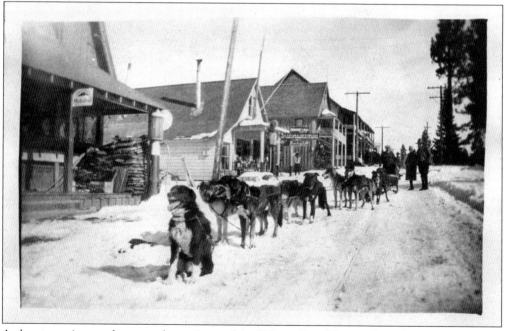

A dog team is seen here on the main road in Tahoe City. The card reads: "About 1925–6 'Scotty' Allen's Dog Team(?). Buildings from left to right: Atherton's Grocery, 'Benny's' Ice Cream and Light Meals, Dance Hall, Tahoe Inn."

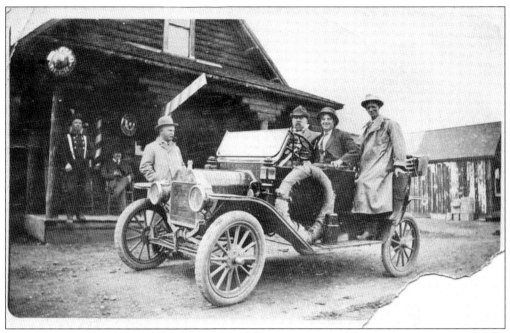

In front of the Tahoe Inn Saloon, these gents in shirt, tie, and coat look more suited for the office than a Tahoe vacation.

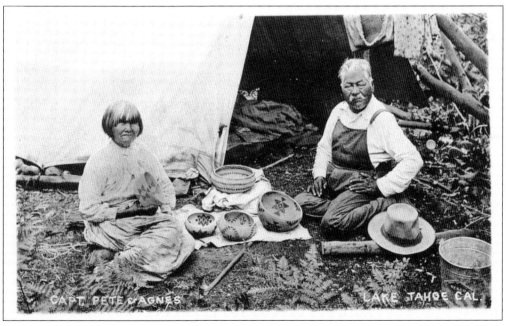

Captain Pete and Agnes were a Washoe couple who summered in the Tahoe City area. Here they are with a variety of Agnes's baskets. The traditional materials for Washoe basketry are willow, bracken fern, and redbud.

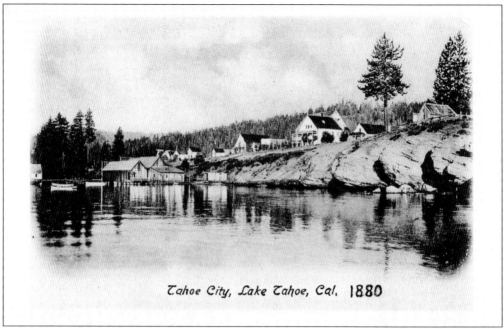

In the early days, there were quite a few buildings constructed over the lake in addition to a number of piers. Here in this *c.* 1880 Tahoe City card, one can see the Swallows Cliffs on the right.

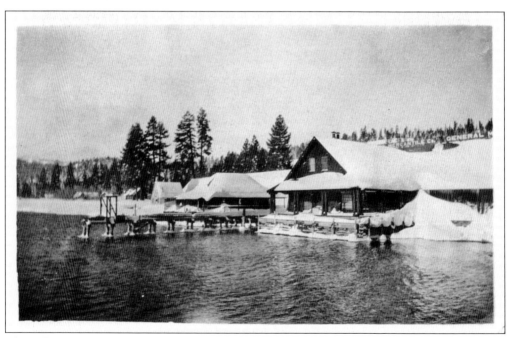

The Tahoe City Mercantile featured everything needed, from groceries to general merchandise. Like many of the early buildings in Tahoe City, the mercantile burned in 1937. The mercantile is on the right, and the Tahoe Women's Club is on the left in the background.

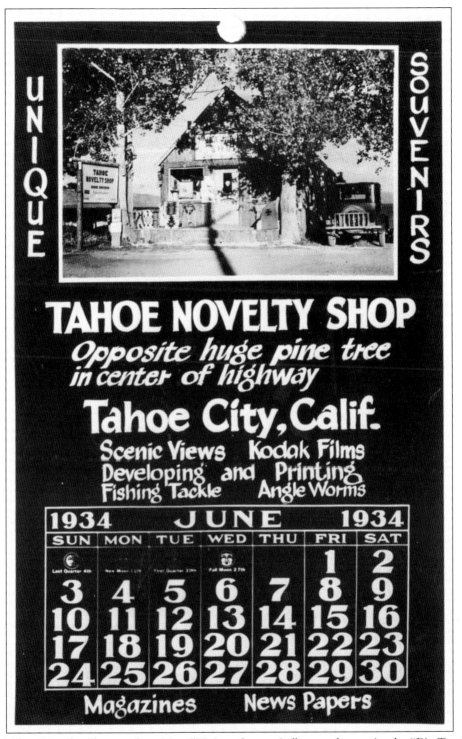

The Tahoe Novelty Shop—advertising "Unique Souvenirs"—stood opposite the "Big Tree" in the center of the highway. Located on what is now Heritage Plaza in Tahoe City, this shop had a spectacular view of the lake.

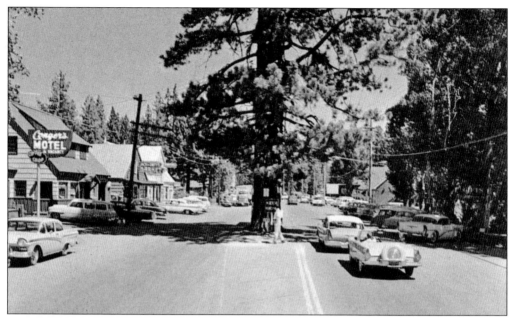

The "Big Tree" was a landmark for generations. This pine lived in the center of what is now Highway 28. Locals petitioned in protest to keep the tree from being taken down for a street-widening effort in 1940. The Big Tree was over 250 years old when it was removed in 1994. The tree suffered because of a very long drought in the preceding years.

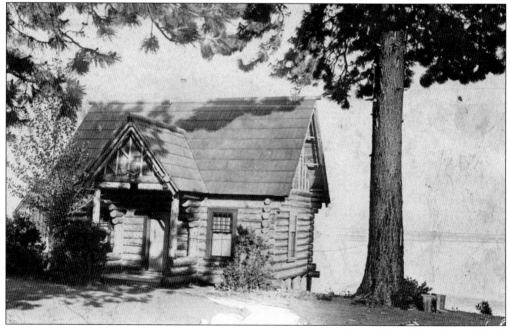

The Watson Cabin was one of the first year-round residences in Tahoe City. Robert M. Watson was the first constable in Tahoe City. He and his son Robert H. built the cabin beginning in 1908 and completed it in 1909. It was finished just in time for the wedding of Robert H. Watson and Stella Tong in June 1909. The cabin is now operated by the North Lake Tahoe Historical Society.

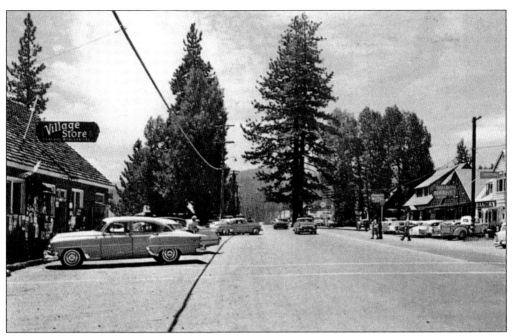

Another view of the Big Tree looks toward Tahoe City. The Village Store on the left is currently Syd's Bagelry. The back of the card read, "Hi Pal, Just a line, it is real nice up here, we had a big fish dinner tonight. We are coming down to pay bills about the 5th then intend to come back until after Gordon's vacation is over. Us gals come over here yesterday and had lunch while the men went fishing. Be seeing you, Love Ruby."

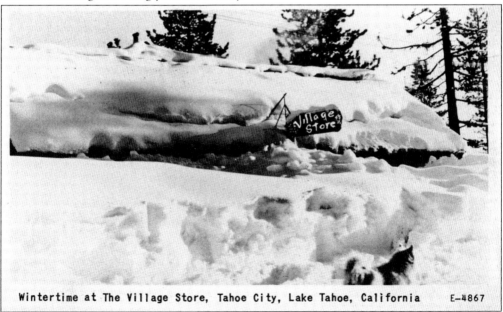

Wintertime at The Village Store, Tahoe City, Lake Tahoe, California E—4867

In contrast to the card at the top, here is a glimpse of life in Tahoe City during the winter. Note the height of the Village Store sign above the street in the summer photograph and its position here. In record years (1880, 1890, 1938, 1952), over 60 feet of snow has fallen at Donner Summit. (Courtesy of Don and Jeanne Davis.)

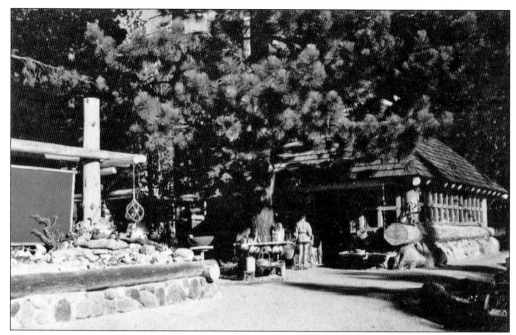

For years, the beloved Bridgetender Restaurant was located adjacent to the Gatekeeper's Museum in Tahoe City. Known for the trees growing up through the building, this quirky spot entertained locals and visitors alike. In its previous lives, it was also known as the Viking Gift Shop, pictured here, and as the Homewood Art Gallery. (Courtesy of Don and Jeanne Davis.)

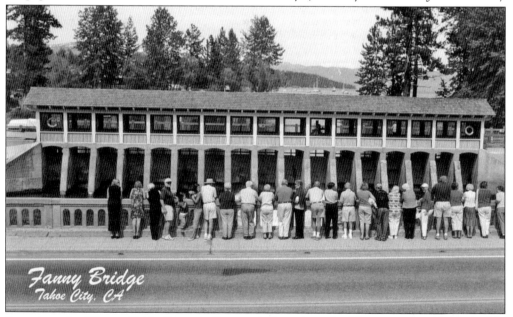

Ever since the "Fanny Bridge" was built, people have been looking over the side at the big trout down below. Well fed from the fish food and scraps thrown over the bridge, the huge rainbow trout glide through the waters. The shutters on the dam were replaced with windows in recent renovations. Our models here are the board of directors, volunteers, a few locals, and staff of the North Lake Tahoe Historical Society in the summer of 2006.

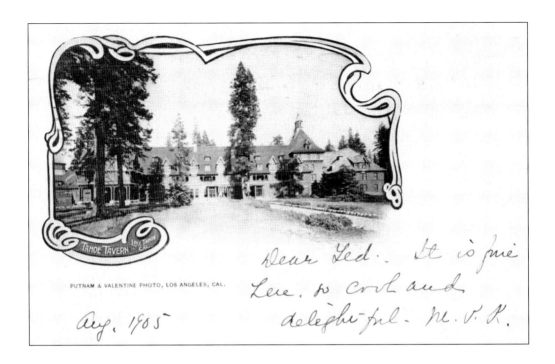

PUTNAM & VALENTINE PHOTO, LOS ANGELES, CAL.

Dear Ted:. It is fine here. So cool and delightful. M.V.K.

Aug. 1905

The Tahoe Tavern was designed by Walter Danforth Bliss, son of Duane L. Bliss, and William B. Faville, Walter's college roommate. Duane L. Bliss, of the Carson Tahoe Lumber Company, formed the Lake Tahoe Railway and Transportation Company for his next adventure in Tahoe. This company was responsible for building the steamer *Tahoe*, the narrow gauge from Truckee to Tahoe City, and the Tahoe Tavern.

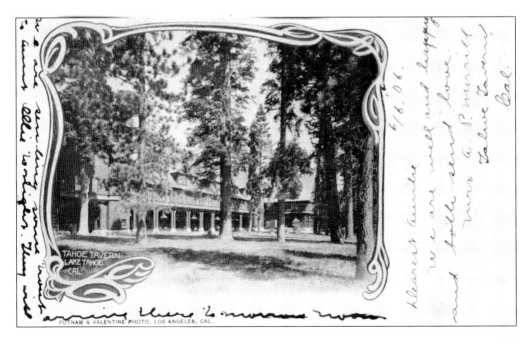

PUTNAM & VALENTINE PHOTO, LOS ANGELES, CAL.

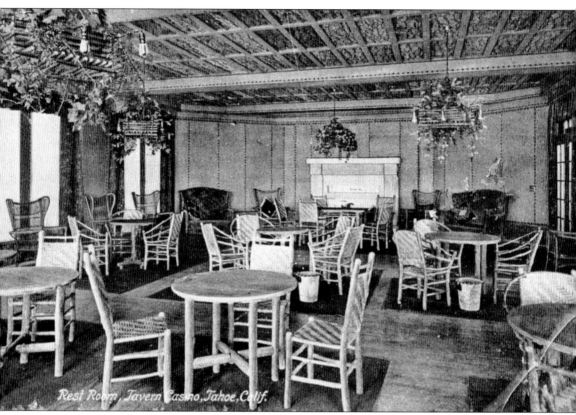

Rest Room, Tavern Casino, Tahoe, Calif.

This room at the Tahoe Tavern featured flower-box light fixtures hung from a bark-covered ceiling and comfortable yet rustic seating. The main hotel building could house up to 450 guests. The grounds were beautifully manicured with rock-lined paths leading guests through the tall pines.

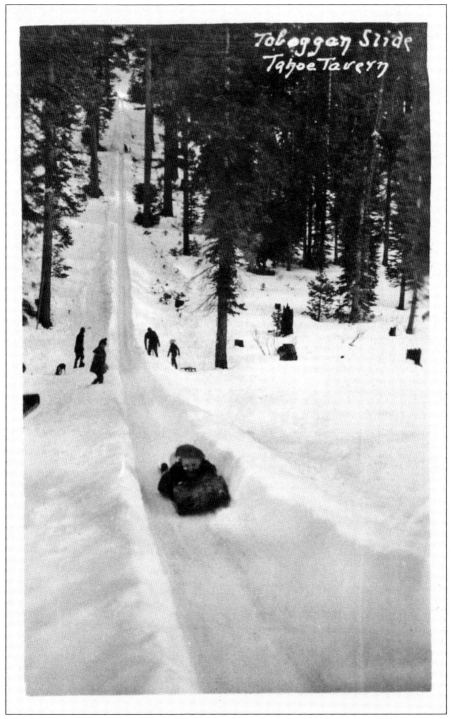

One and a half miles at 50 miles per hour was the attraction at the Tahoe Tavern's toboggan slide. The winter amenities at the tavern included skiing, sleigh rides, and the toboggan run. Winters were not as busy as the summer season at the lake, but winter sports gained popularity over time.

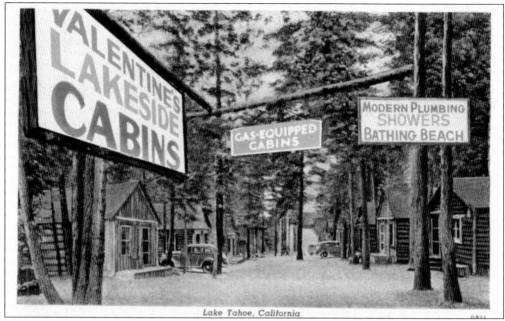

Lake Tahoe, California

Valentine's Lakeside Cabins were typical of many of the accommodations around the lake. This resort was made up of small cabins, which were a nice step up from a tent cabin. These structures could cozily house a family for the duration of their trip. (Courtesy of Don and Jeanne Davis.)

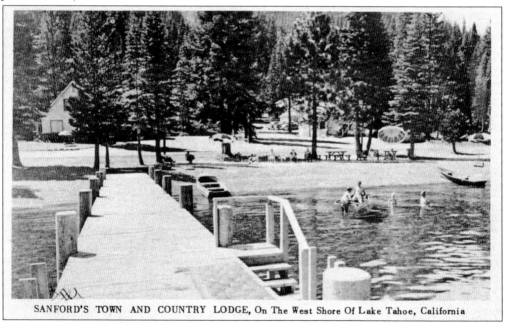

SANFORD'S TOWN AND COUNTRY LODGE, On The West Shore Of Lake Tahoe, California

Sanford's Town and Country Lodge, on the west shore, was located three miles south of Tahoe City. One brochure states, "Fishing. Old timers are on hand to steer the amateur to where the fish are biting. In hundreds of streams and small lakes surrounding Lake Tahoe . . . Rainbow, Eastern Brook, Salmon, Makinaw, German Brown, Loch Leven, are some of the many fish that can be caught in the lake and streams of Tahoe." (Courtesy of Don and Jeanne Davis.)

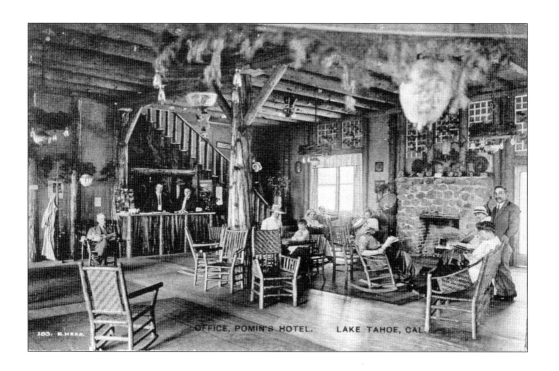

Pomins later became known as the May-Ah-Mee Lodge. May-Ah-Mee is said to have been a Native American name for edge of the lake, though no one is sure with which tribe it originated.

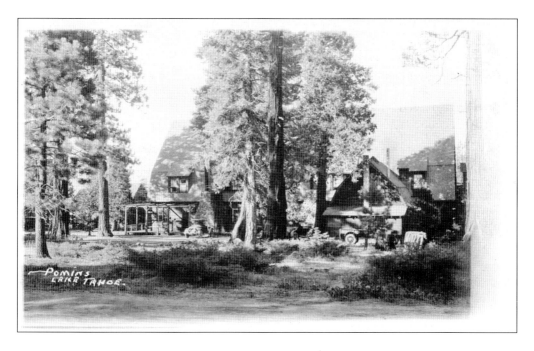

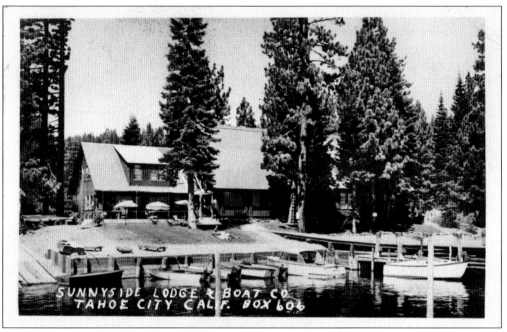

The Sunnyside Lodge and Boat Company, pictured in the mid-1950s, was a popular spot to relax. The back of the card reads, "8 -1-57, Dear Goldie—Reached here this a.m. a very nice comfortable place. Expect the Coopers in the morning. The Lake is so blue. Don't work too hard you and Neal. Love, Essie and Russ."

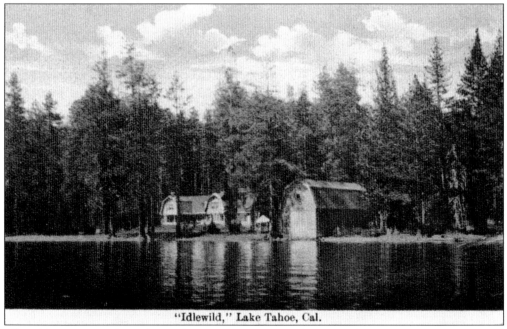

"Idlewild," Lake Tahoe, Cal.

Idlewild was named by Judge and Mrs. Edwin B. Crocker in the late 1800s. Idlewild's social activities flourished for nearly a quarter century, with the Crockers' daughter, Aimeé Ashe Gillig Gouraud Miskinoff Galitzine, as the social director.

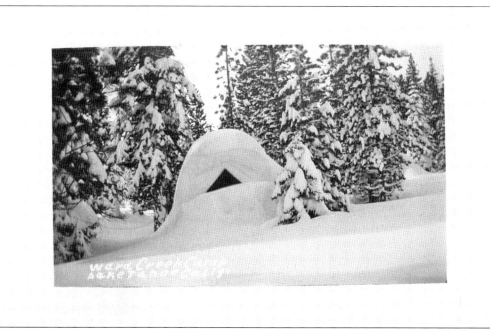

Ward Creek Camp was named for Ward Rush, who homesteaded over 160 acres in the area in 1874. There was a lumber mill in this area and a spur of the Lake Tahoe Railway and Transportation Company narrow gauge. (Courtesy of Don and Jeanne Davis.)

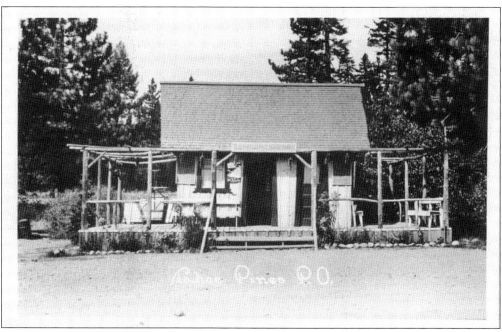

Idlewild officially became Tahoe Pines with the establishment of this post office in 1912. Tahoe Pines was the first mail stop for the mail boat, which ran counterclockwise around the lake.

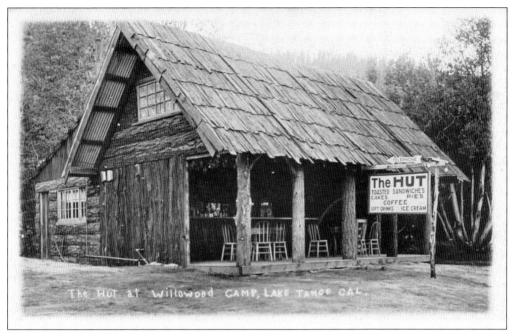

The Hut at Willowood Camp was run by the Callender family for many seasons. According to E. B. Scott, heavy winters leveled the Homewood Casino in 1936 and Ben Callender used the timber to build the Hut.

Many of the early homes and lodges featured expansive porches where vacationers could relax and absorb the beautiful surroundings. Sadly, many of Tahoe's original structures were not built to withstand the harsh winters and subsequently collapsed.

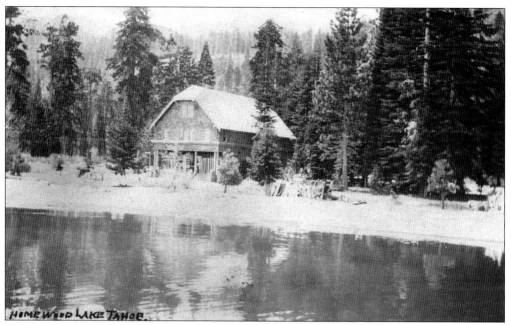

Homewood Hotel was built in 1910 by Annie and Arthur C. Jost. Later a large casino and dance floor were added across the road. In 1938, Annie Jost sold to Mr. and Mrs. Donald Huff of Woodland, California. (Courtesy of John Rauzy.)

In the center left of this view from the lake, Homewood has been spelled out in pinecones hanging above the dock. The Homewood Post Office was established in 1909. Early residents included Ed and (Dr.) Etta Farmer, Senator Voorhees, Adolph Mueller, "Peg Leg" Saunders, the Prentiss family, the Holabirds, and the Blacks.

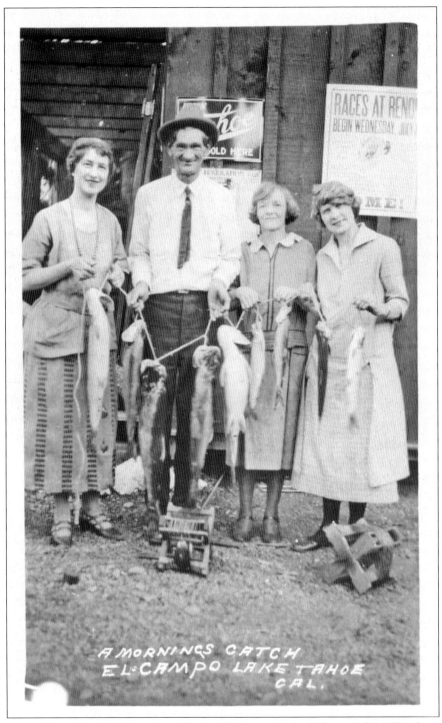

A MORNINGS CATCH
EL CAMPO LAKE TAHOE
CAL.

This postcard is entitled "A Mornings Catch, El Campo Lake Tahoe, Cal." Bill Johnson and fisherwomen pose with nine fine specimens. E. B. Scott reported that Johnson "hid a bottle of 'Sierra chain lightning' under a different log each day, barely keeping one log ahead of the Federal officers."

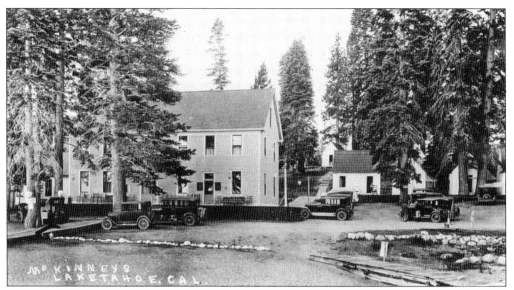

McKinney's Resort was named for owner-operator John Washington McKinney. In 1863, he established Hunter's Retreat, which eventually became a hotel, dance pavilion, and guest cottage as well as an over-water bar, barbershop, and post office. William Westhoff took over in 1892, followed by the Murphy brothers in 1893 and David Henry Chambers in 1920. Chambers upgraded and operated the resort until his passing in 1952, when his brother George took over until its sale in 1956 to Thomas G. Stone.

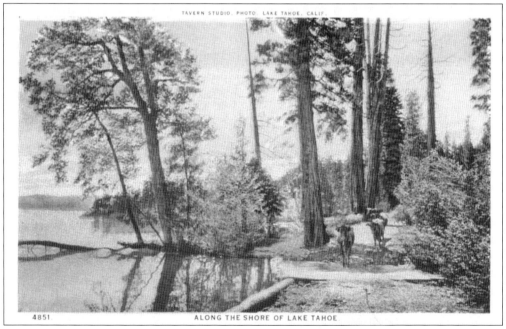

Along the shore of Lake Tahoe, it may be difficult to distinguish the cows walking down the path on this card. It is amazing that cattle were driven up to grazing areas at the lake when it seems like it would have been such a challenge to reach. The card caption reads, "At points in its course around Lake Tahoe the Lincoln Highway almost dips into its shallow waters and the reflected shoreline is as vividly distinct as the original." (Courtesy of Don and Jeanne Davis.)

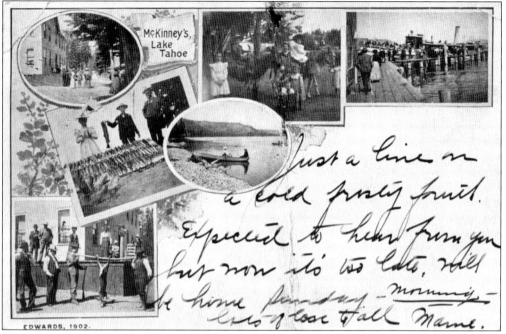

This McKinney's Lake Tahoe 1902 photograph collage shows plentiful fishing, a crowded pier of guests meeting the steamer *Tahoe*, riders on horseback, a deer shot on a hunting expedition, and a boater. (Courtesy of Don and Jeanne Davis.)

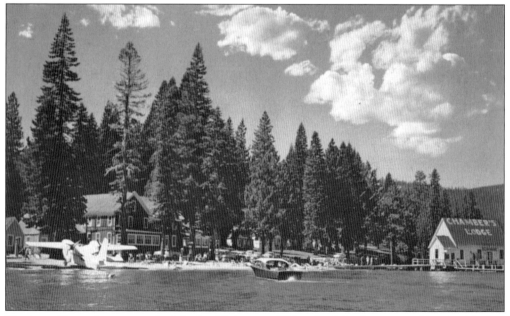

The bar still stands out over the lake in this image of Chamber's Lodge, a rare thing in this day. There are only a handful of establishments that are still accessible from the lake, and this is one. In the early days, one of the easier ways to get around was by using the lake; therefore, it was not uncommon for business and hotel structures to be built on piers over the water.

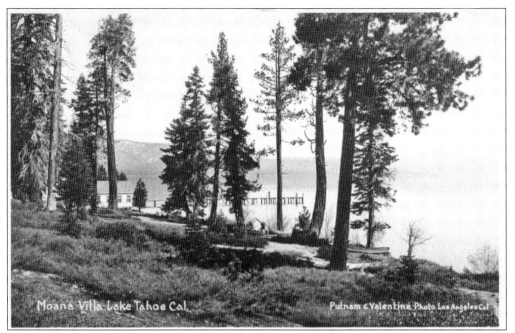

Moana Villa was established in 1894. This hotel consisted of a main lodge, cottages and tents, a clubhouse over the water, plus a 500-foot pier to accommodate the steamers.

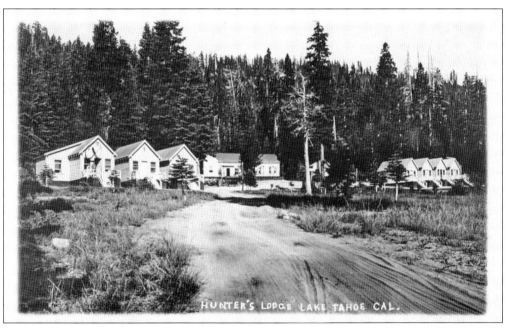

Hunter's Lodge was run by John W. McKinney and opened before Moana Villa. Both resorts hosted visitors who made their way to Tahoe via Rubicon Springs. The back of the card reads, "Aug 5 -30 Dear Daisy: I have marked our cottage with an 'x.' This spot is very beautiful and the weather is too. There is a nice dining room here and the cottages are like a fine apartment. I hope to visit every resort tomorrow. Albey."

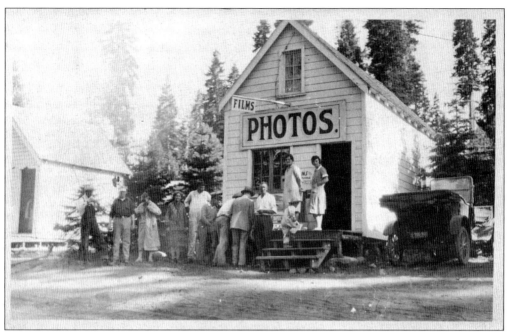

In this lovely image of Tahoma, the back of the card reads, "Mom Plannet, Marie Henry on porch, Pat going up stairs to look at pictures of Aimie McPherson. Tahoma—Lake Tahoe. Mr. Ned Johnson's Photograph Shop. Model T is the car, the year 1926."

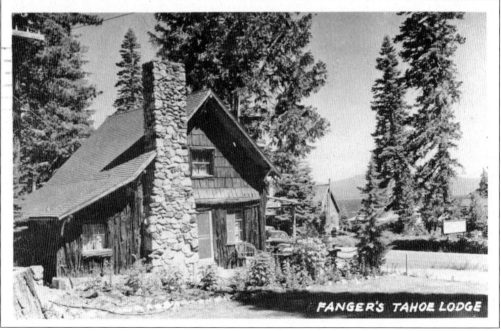

This Fanger's Tahoe Lodge card reads: "July 9, 1950—Dear Madge: Just had two very nice weeks at Tahoe and are now in Sacramento. To-day we visited the State Dept. of Educ. To-morrow we're going to San Francisco and Bay Area. Am happy not to be in S. School. Sincerely, Grace." (Courtesy of Don and Jeanne Davis.)

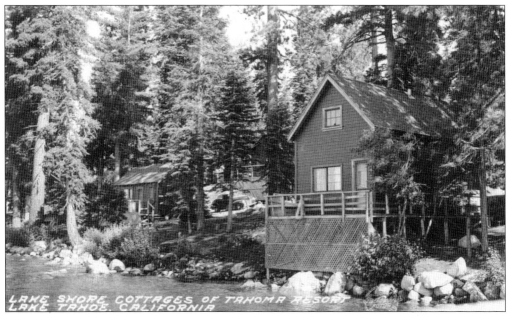

Joseph Bishop purchased the land between Moana Villa and Pomin's Lodge and called it Tahoma. He is said to have named the site Tahoma since it was a place away from home that would mean home to his guests. The hotel and cottages opened in 1916 and grew to include a dance hall, a dining room, and a swimming pool built out into the lake. (Courtesy of John Rauzy.)

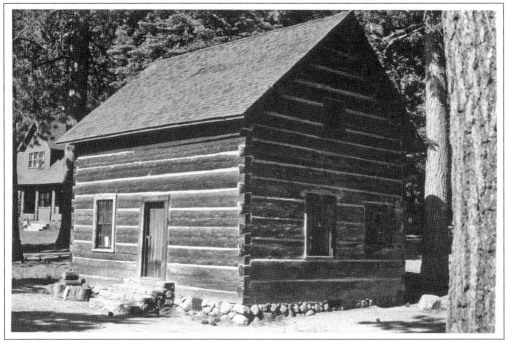

The General Phipps Cabin, at Sugar Pine Point State Park, was built in 1872. This was Gen. William Phipps's second home on his 160-acre homestead at the mouth of General Creek. He was locally famous as a marksman, hunter, and fisherman. The Bellevue Hotel operated here from 1888 until its demise by fire in 1893.

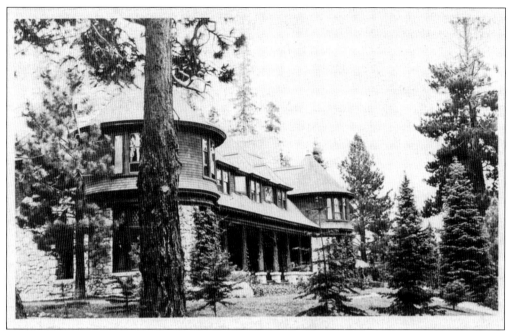

Pine Lodge, a grand summer retreat, was designed by William Danforth Bliss and built for Isaias William Hellman. The mansion is located north of the original Bellevue Hotel site. The Hellman compound consisted of a number of outbuildings as well as a tennis court. A flume from General Creek provided water. The estate totaled 2,021 acres. It is now operated by California State Parks.

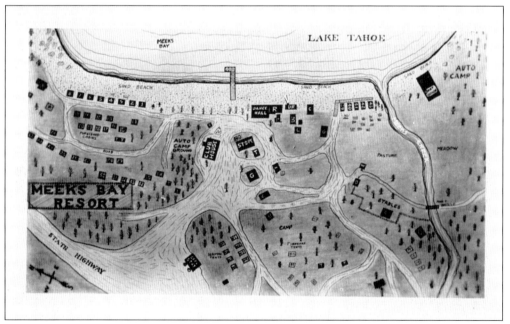

This map shows Meek's Bay Resort, where lush meadows nearby served as grazing land for the Murphys' and Morgans' dairy cows. "Buttermilk Bay" was one of the nicknames for this area. (Courtesy of Don and Jeanne Davis.)

The Sport Hall at Meek's Bay Resort sported the massive cedar tree shown here to the right of the chimney. For generations, Meek's Bay was a summer campsite for the Washoe.

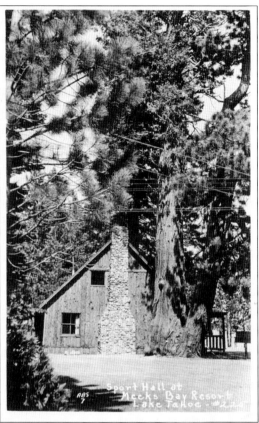

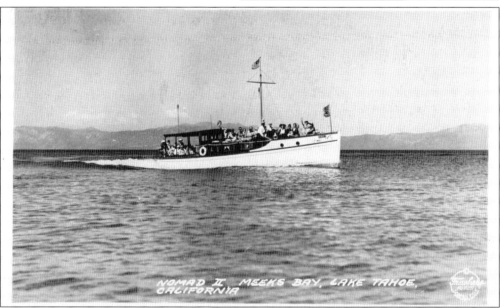

Many of the early resorts provided pleasure boat excursions for their guests. Here is the *Nomad II* from Meek's Bay, which appears to be packed with visitors. (Frasher Fotos, courtesy Don and Jeanne Davis.)

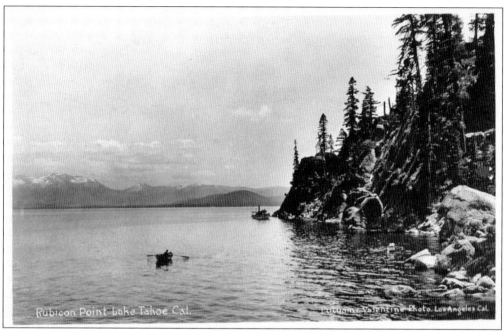

Putnam and Valentine operated a studio at the Tahoe Tavern. They produced a multitude of images provided as postcards and prints for framing. Rubicon Point was often photographed with its sheer granite cliffs.

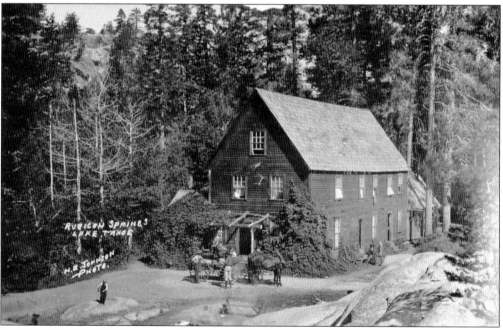

Rubicon Springs, for the rugged traveler, offered a way station for one of the alternative approaches to Tahoe from Placerville. The trek took travelers through the Rubicon wilderness from Placerville, depositing visitors on the west shore as opposed to the north or south. The Rubicon area is now known for its jeep trails.

Three

EMERALD BAY TO STATELINE

Emerald Bay has been a tourist destination for generations. It is the home of Lora Knight's Vikingsholm, which is under the jurisdiction of the California State Parks. A mile walk down from the highway offers much anticipation of what one will find below. Knight's grand home was quite a feat to build. Supplies were brought by train and then by barge to her lakefront setting. The south shore was more difficult to access by "mass transit" in the early days. The first visitors from Placerville came by horse or stagecoach and later by Pierce Arrow Stage lines. Visitors coming from other regions would take the train to Truckee and then board the narrow-gauge rail to Tahoe City, where they would board the steamer *Tahoe*, which delivered them to their destination. The earliest lakefront establishments were Yank's Place at Tallac Point, later purchased by Lucky Baldwin, who owned about 6,000 acres from what is now known as Pope Beach up to Taylor Creek and into the Fallen Leaf Lake area. Celio Ranch provided fresh vegetables and other farm goods for the local resorts.

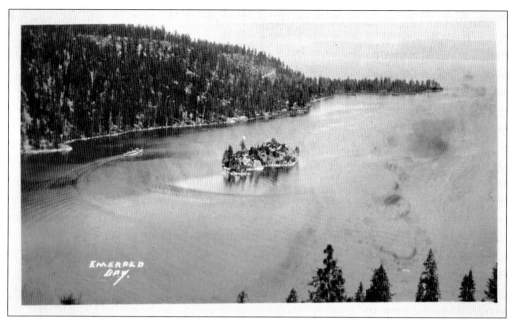

This view of Emerald Bay shows Fanette Island with a steamer heading around the island. Emerald Bay has frozen over on just a handful of occasions. It is one of the most popular spots by land and water for visitors to the lake.

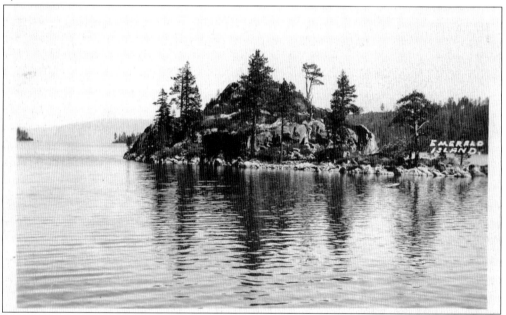

Fanette Island has a number of names, including Coquette Island and Emerald Island. Capt. Dick Barter fashioned himself a grave where he asked to be put to rest. He was known as the "Hermit of Emerald Bay" and was a caretaker for the Holladay residence for many years. He had one near-death experience after rowing home from a bar on the northwest side of the lake when his boat capsized. In another incident, on his way back from a saloon on the south shore, he would not be as lucky. His sailboat was crushed, and only one intact oar was found months after his disappearance.

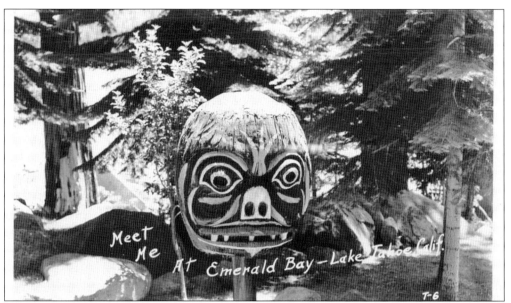

Here is a striking view of the totem pole at Emerald Bay. Lake Tahoe was the backdrop for much of the classic 1936 movie *Rose Marie*, starring Nelson Eddy and Jeannette MacDonald. The drum dance scene was filmed at Emerald Bay, and many totem poles were fabricated for the event. The totem poles can still be found in various locations around the lake. (Courtesy of Don and Jeanne Davis.)

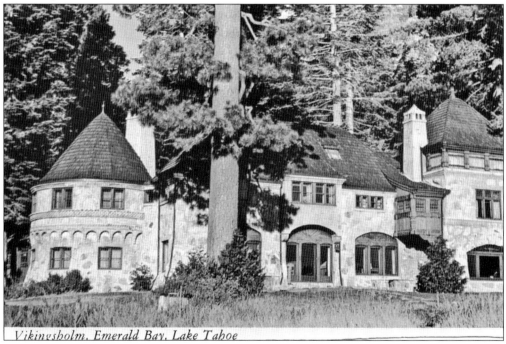

Vikingsholm at Emerald Bay was built by Lora Knight in the tradition of Scandinavian design. Planned down to the smallest details, with hand-carved woodwork, the building had painted beams, ironwork, and a sod roof. It is now operated by the California State Parks; visitors may tour the mansion in the summer months.

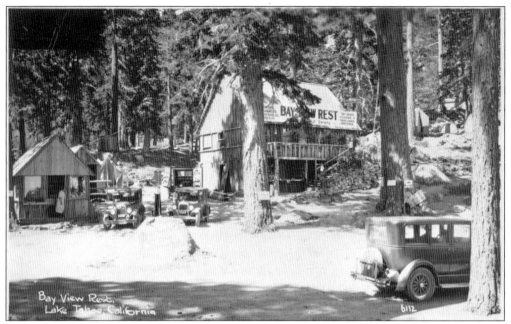

Bay View Rest was located on the southeast side of Emerald Bay. Here one can see the grocery store and a "tent house" in the distance (right). Parts of this resort were also included the filming of *Rose Marie*.

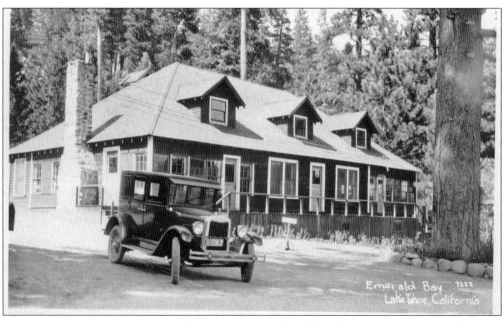

Here is another of the original buildings of the early Bay View Rest resort at Emerald Bay.

The Emerald Bay Resort was located on the northwest side of the bay. The buildings were on pilings over the bay. Built in 1884 by Dr. and Mrs. Paul T. Kirby of Carson City, it was comprised of a small hotel, cottages, tents, and a pier. In 1913, Rim of the Lake Drive around Emerald Bay was completed. According to E. B. Scott in *The Saga of Lake Tahoe, Volume I*, "It took 50 cases of dynamite to break one granite boulder into four pieces, and regular steamer excursion were run to the bay so that tourists could watch, goggle-eyed, as thousand of tons of rock lifted into the air and thundered down the mountainside." (Frasher Fotos.)

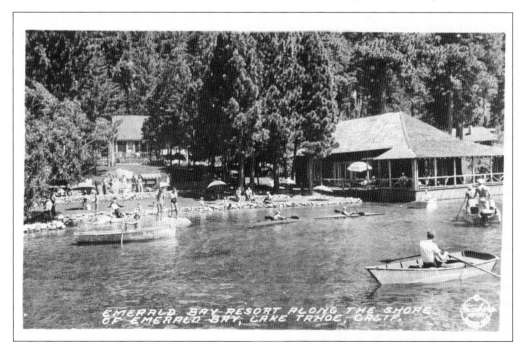

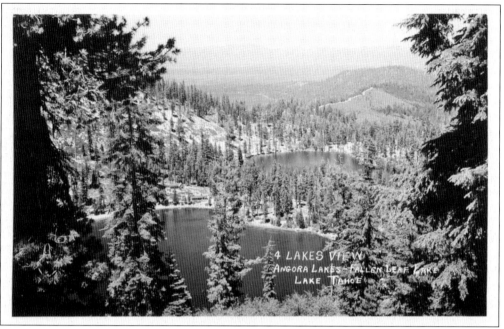

This card shows Angora Lakes in the foreground, Fallen Leaf Lake barely visible in center (near top), and Lake Tahoe below the ring of mountains at the top of the card. This photograph was taken from the Desolation Wilderness comprised of 63,960 acres of sub-alpine and alpine forest, granite peaks, and glacially formed valleys and lakes.

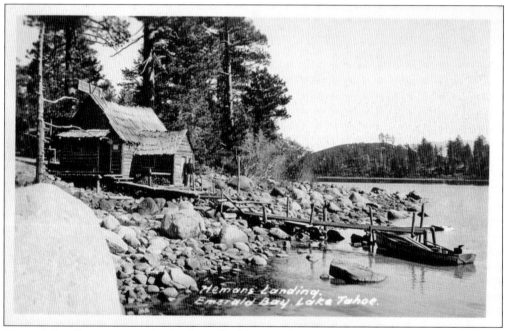

Heman's Landing was a scenic site from the filming of *Rose Marie* (1936) at Emerald Bay. Lake Tahoe scenery has been used in over 75 films since 1915. Nearby Cascade Lake was the setting for parts of *Lightin'* with Will Rogers. (Courtesy of Don and Jeanne Davis.)

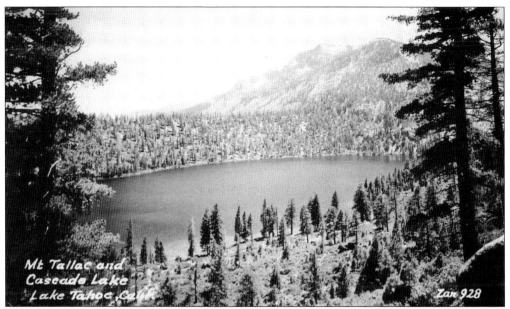

Mount Tallac and Cascade Lake are shown here. Cascade Lake is one mile long by half a mile wide and has been known as Silver Lake. It was used as a fishing spot for guests of the Tallac Hotel. Land surrounding the lake was purchased by Dr. Charles Brooks Brigham of San Francisco beginning in 1882. Brigham had many notable guests at his summer home, including John Muir and Mark Twain.

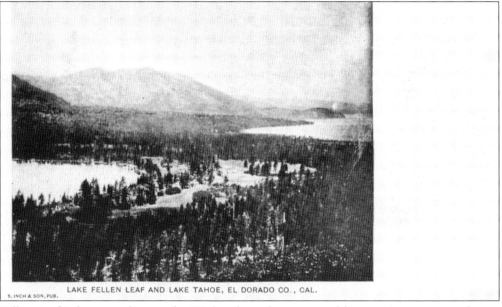

LAKE FELLEN LEAF AND LAKE TAHOE, EL DORADO CO., CAL.

Fallen Leaf Lake, according to the Washoe legend, was named because it sprang up where a leaf fell from a branch carried by a brave fleeing the Evil One. He was instructed to drop a leaf embodied with magical powers of the Good Spirit if he encountered Evil. When a leaf was dropped, it turned into water. He dropped a large leaf, and Lake Tahoe was formed; along with Fallen Leaf, his magical leaves formed Lily, Grass, and Heather Lakes above in Desolation Wilderness.

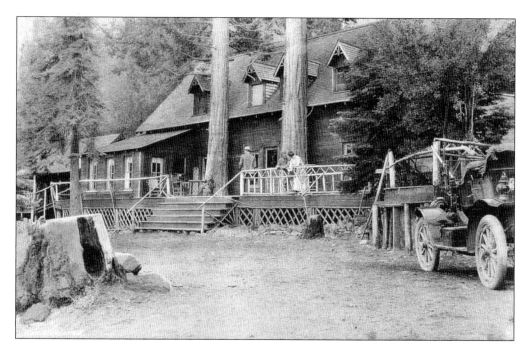

Fallen Leaf Lake Lodge was started by William Whitman Price, who had also opened a boys' summer camp called Camp Agassiz below Glen Alpine. The lodge was operated by the Price-Craven family for decades and was known for its family-style hospitality and natural beauty of its secluded locale. Faculty from Stanford University acquired a parcel of land nearby and began erecting summer cottages there (now known as Stanford Camp). The road leading into this area remains a one-lane road today, which no doubt helps the lake retain its seclusion.

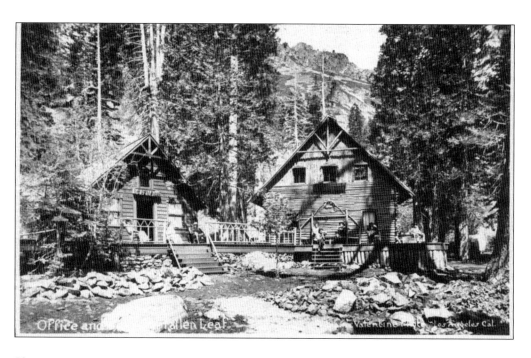

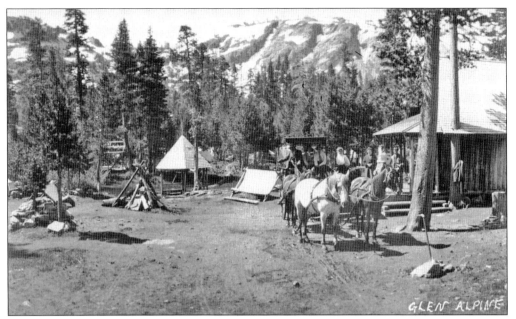

Glen Alpine Resort was known later for buildings designed by noted architect Bernard Maybeck, but originally it was known for the spring. The journey to this resort is still rough, with the last mile being a rocky uphill climb. It must have taken guests many hours to arrive at the location from the main road by the lake.

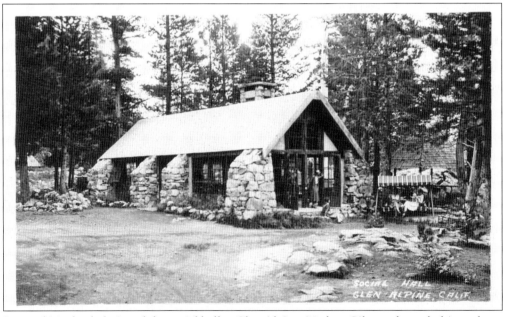

Bernard Maybeck designed the social hall at Glen Alpine. Nathan Gilmore brought his cattle up from Placerville to graze in this area in 1863. By 1880, Glen Alpine Tonic Water had become famous in California and Nevada, and slowly a resort began to develop. (Frasher Fotos.)

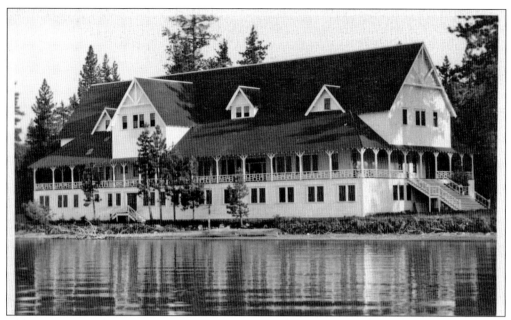

Tallac Casino was in the height of its glory in 1906. One of the original brochures reads, "The Tallac has the finest casino in America for the amusement of its guests; it is 176 feet long and 72 feet wide, 2 stories high, all finished in natural wood with hardwood polished floor throughout; contains ballroom, ladies' billiard and pool room, four latest improved bowling alleys, sun parlors, stage and dressing room for theatricals, $10,000 worth of French plate mirrors and 500 electric lights."

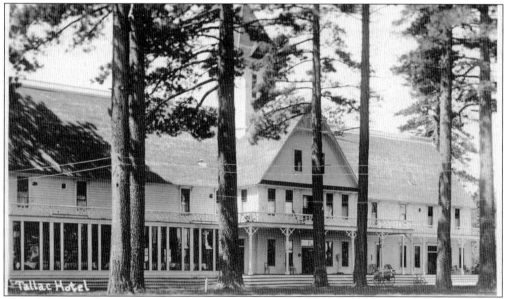

Visitors can still see the foundation stones from the Tallac Hotel, which was set back from the lake adjacent to what is now the parking lot for the USDA Forest Service–operated Tallac Historic Site. A paved promenade connected the hotel with the casino. An exhibit at the Baldwin Museum explains that the ladies would change clothes multiple times throughout the day, and the men would "troll for school marms" along the promenade.

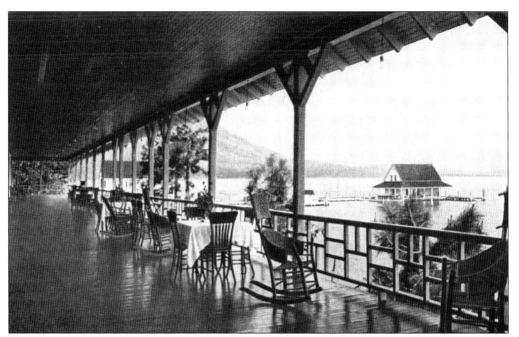

The veranda of the Tallac Casino is seen in this card postmarked 1908. The postcard reads, "Dear Friend, Mr. Van sends the tree down on 212 today. It is sent to Mr. R. in care of Mr. Waddell and left at the depot. All well. Be sure to let us know if you get it. Lovingly, Auntie Van (12-19-08)."

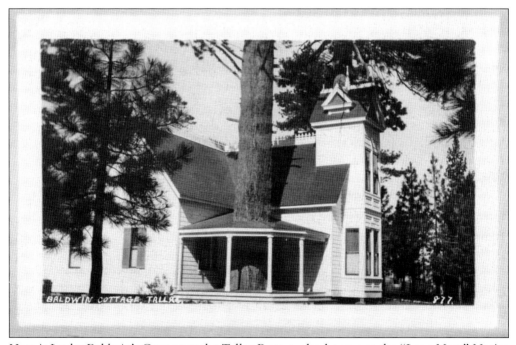

Here is Lucky Baldwin's Cottage at the Tallac Resort, also known as the "Love Nest." Notice the tree growing up through the porch. One can still visit the foundation of the building and the casino on the grounds of the Tallac Historic Site.

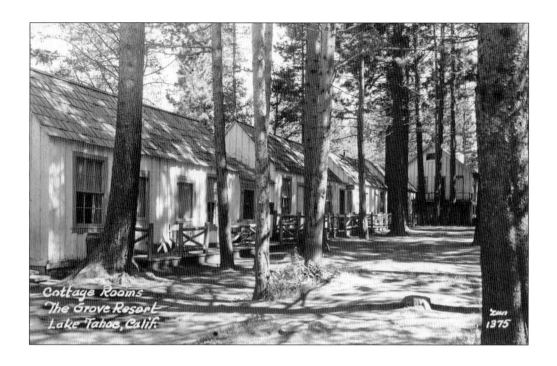

Here are the cottage rooms at the Grove Resort. The Grove preceded Camp Richardson Resort, adjacent to the Tallac Historic Site. A lighted lakeside dance floor drew guests as well as visitors from other parts of the lake. (Courtesy of Don and Jeanne Davis.)

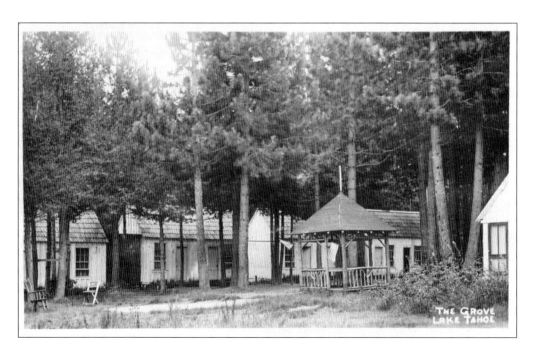

Pictured here is Camp Richardson Resort. The view from Highway 89 shows the building at far right, which still exists, and the picket fencing, which does not.

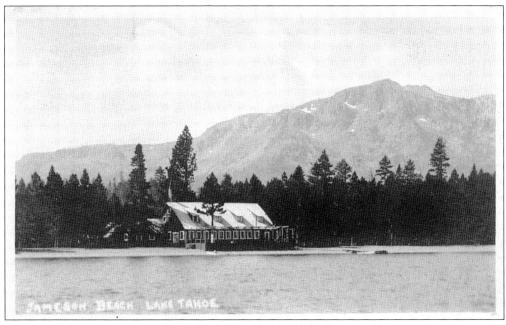

Jameson Beach is a curious enclave consisting of a handful of houses along the lakeshore to the east of Camp Richardson.

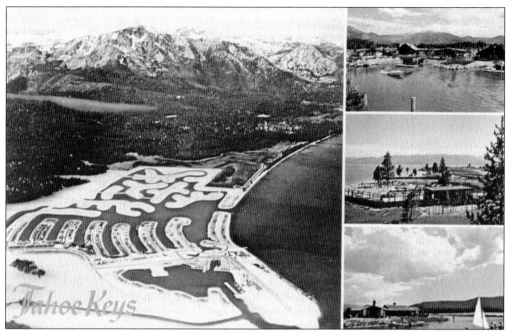

The back of this Tahoe Keys advertising card reads, "Lake Lagoon Living. Tahoe Keys the ultimate in mountain/marine living! A 197 million dollar master-planned community on the south shore of Lake Tahoe. Waterfront home sites, homes and Town Houses with private lake beach, SunBear Swim & Tennis Club and private boat docks. A project of the Dillingham Corporation of California."

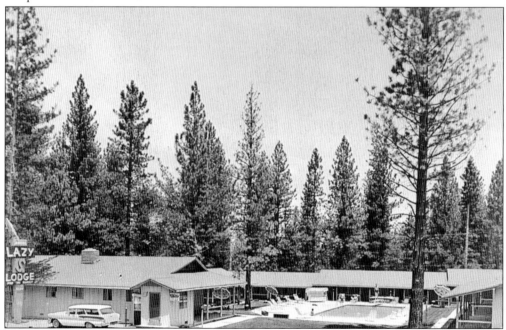

Here is the Lazy S Lodge; the back of the card reads, " 'For the family,' in the woods on hiway 89 South Lake Tahoe. Large modern housekeeping units—luxurious studio rooms—Heated pool—Children's Playground."

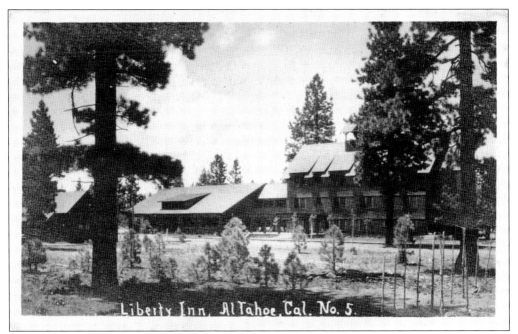

Postmarked September 1, 1913, this card of the Liberty Inn reads, "Dear Mother, It is now Labor Day 8:00 in the morning. Suppose everyone is there by now. We are just starting for home. Left Sat. night came up 7394 ft & then down to about 6225 & camped near this hotel last night, just dandy. Love M."

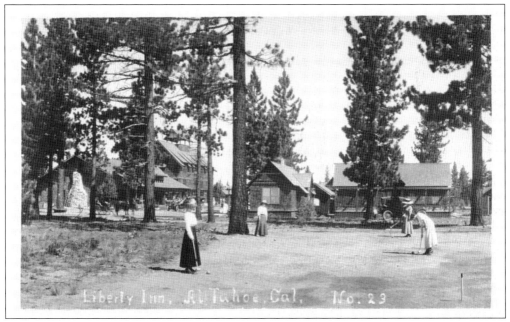

In this card, ladies at the Liberty Inn are enjoying a game of croquet. Note the automobiles and the horse and buggy in the left background of this *c.* 1910 image. Al Sprague completed the hotel in 1908 and added his first name to "Tahoe" to give this area the name that still holds today—the Al Tahoe.

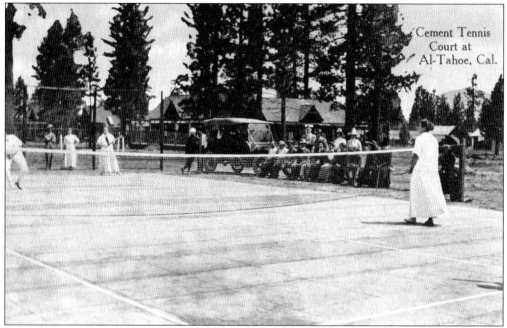

The Globin family took over the Liberty Inn in the mid-1920s. It was also known as the Al Tahoe Inn. After the Globins purchased the property, it was expanded to the lake.

The post office opened in Al Tahoe in August 1908. The hotel was situated on land that originally belonged to the Rowland family, who also operated Rowland's Lake House and Station, built in the late 1850s.

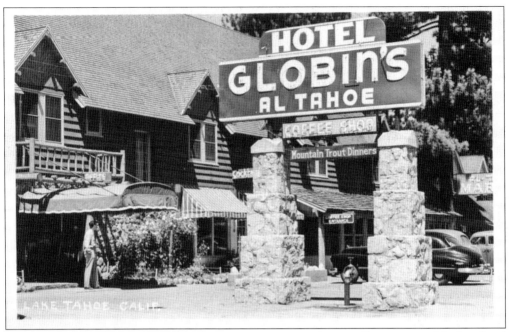

Globin's Hotel was nearly decimated by fire in the spring of 1956. All remnants of the hotel and establishment had virtually disappeared by early 1970. (Courtesy of Don and Jeanne Davis.)

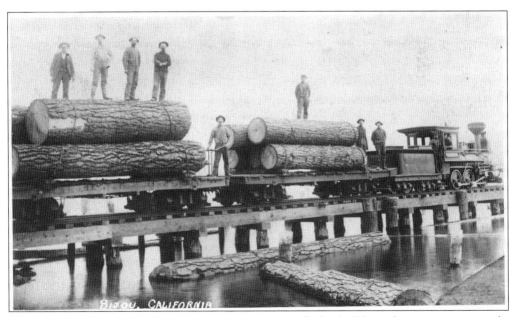

The lake was dotted with logging operations, many of which did not leave a trace as tracks were pulled up and used again in other areas. Bijou was a hub of logging operations, and the Lake Valley Railroad helped to move the timbers. (Courtesy of John Rauzy.)

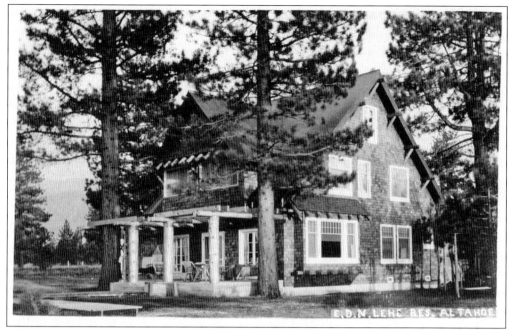

Architecture in Tahoe varied from tent cabins to the very grand. Many of the early homes were built on post and pier "foundations" and were not necessarily built for Tahoe winters. Consequently, very few of the early homes were able to stand the test of time.

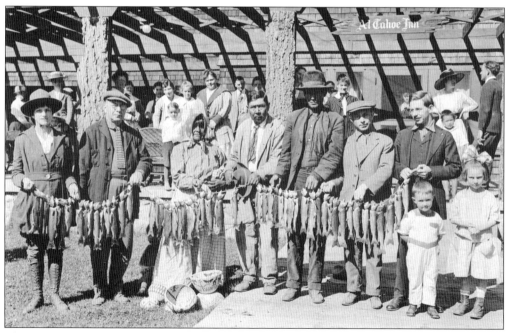

This postcard from Al Tahoe Inn shows one of the great Washoe weavers (center left), Sarah Jim Mayo, with a few of her baskets at her feet.

El Dorado Beach looks very much the same today minus a few of the boathouses and piers in the distance.

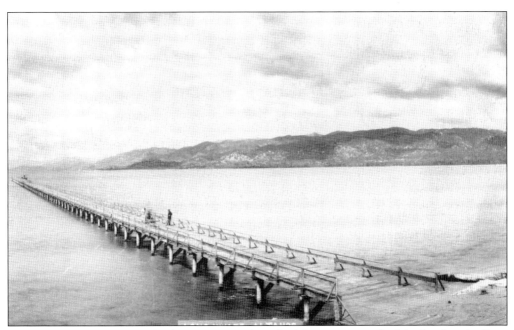

Long piers at the lake were built to accommodate the lake steamers. The lake level varies from year to year, so it was important to allow enough space for the boats to have access in a variety of depths.

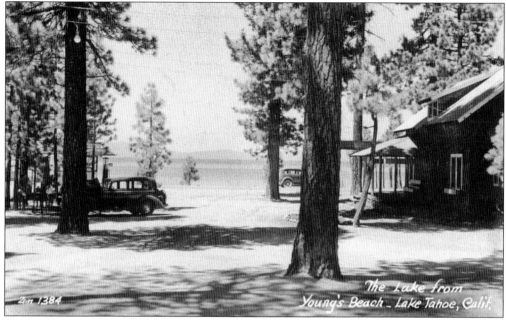

The Young brothers purchased furniture from the Rubicon Park Lodge for their new lodge. The Young family acquired about 30 acres on the lake after the logging operations pulled up stakes. The Young Brothers Lodge opened in the early 1900s.

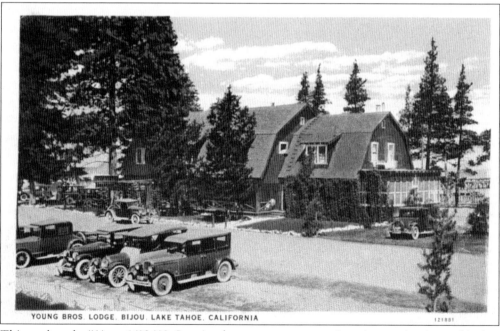

This card reads, "11pm 6/13/40. Leaving here tomorrow morning. Am staying in a cabin just next door to the one shown in the picture on other side. Have blues today. Seems like the world is all wrong. Maybe it's me. War news doesn't help either, Love Leslie."

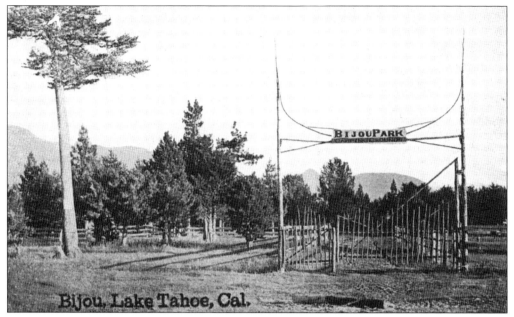

Bijou, Lake Tahoe, Cal.

The Bijou area was said to have been given its name in the late 1800s. In French, it means gem, jewel, or treasure; perhaps it was named by the French-speaking loggers. Carson and Tahoe Lumber and Fluming Company and Nevada Lumber Company were two of the logging companies hard at work in this area in the late 1800s.

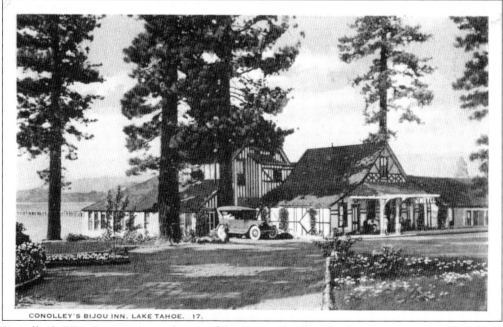

CONOLLEY'S BIJOU INN. LAKE TAHOE. 17.

Conolley's Bijou Inn was located west of the Young Brothers Lodge. It was operated by Annie and William F. Conolley. It was a resort hotel and campground featuring daily chicken dinners and floored tents.

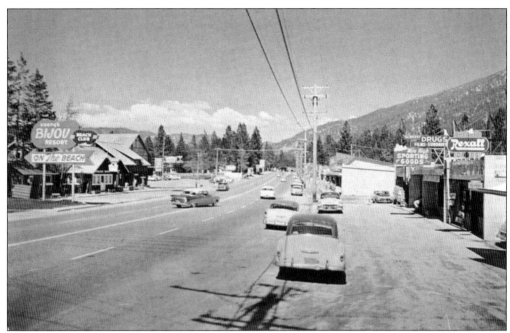

In a dramatic transition from the dirt road days, shops and resorts lined Highway 50 by the 1950s.

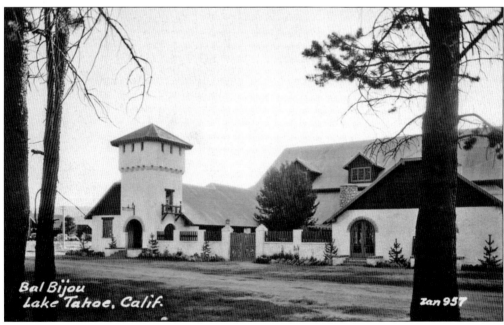

Bal Bijou, originally Young Brothers Lodge, stood out from the traditional architecture in the area. Bijou was also known for having the largest dance pavilion on the lake.

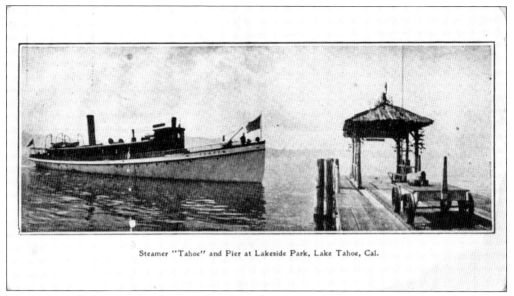

Steamer "Tahoe" and Pier at Lakeside Park, Lake Tahoe, Cal.

The steamer *Tahoe* and the pier at Lakeside Park are seen in this card. The steamer delivered mail, supplies, and passengers around the lake year-round. The handcart is visible on the right running on tracks to ease the delivery of mail, freight, and goods to the shoreline.

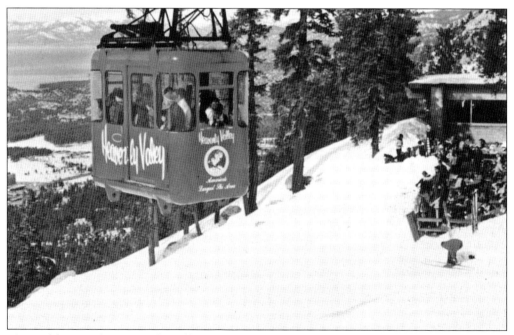

Pictured here is the Heavenly Valley Tram. The upper station serves the skiers in winter and vacationers in summer.

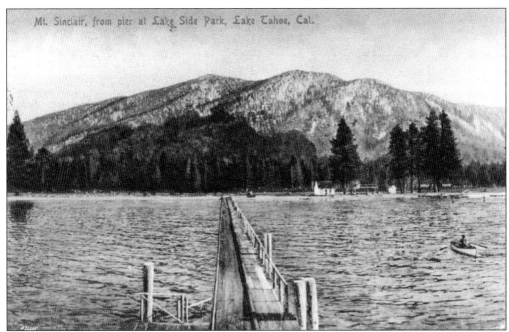

Mount Sinclair, at a pier at Lake Side Park, Lake Tahoe, is seen here in a card postmarked in 1909. The card reads: "Dear Aggie, I see by Mama's letter that you are home again. Glad you had such a nice journey and know you must have enjoyed yourself. I will be glad to see you when I come home. This is where I am and our tent is up among these pine trees. We are having a fine time and I feel so well. Love to you—Florence."

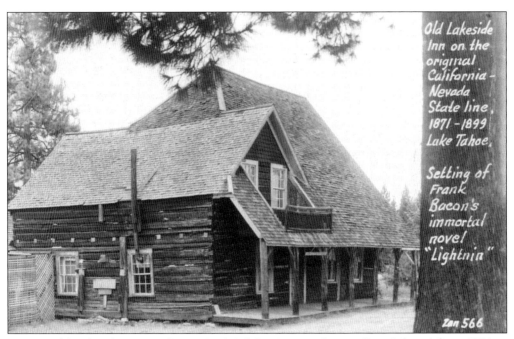

Here is Old Lakeside Inn on the original California-Nevada state line; it lasted from 1871 to 1899 and was the setting of Frank Bacon's immortal novel *Lightnin.*

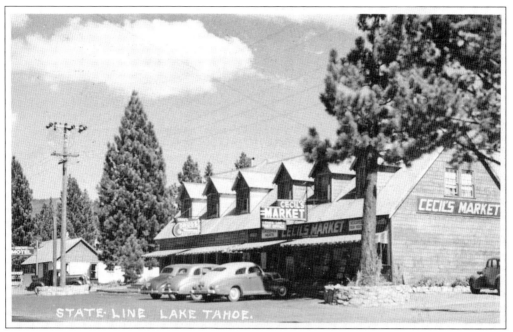

This image of the state line shows Cecil's Market on the California side of the line. The original building was demolished as part of the recent revitalization of the casino corridor. The market has a new home in the Heavenly Village. (Courtesy of John Rauzy.)

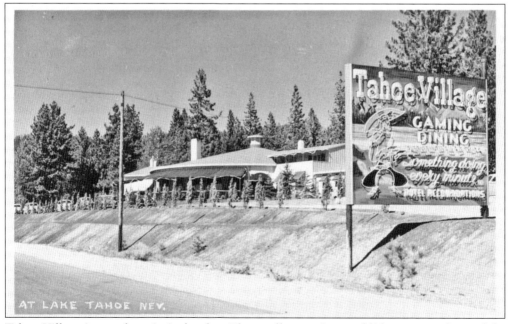

Tahoe Village is seen here in its heyday. The smaller gaming establishments are few and far between since the larger casinos moved in or grew out of their modest beginnings. (Courtesy of John Rauzy.)

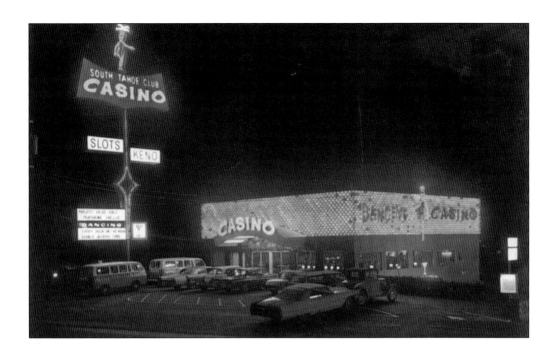

The small South Tahoe Club Casino (above) and the Tahoe Colonial Club (below) seem quaint by today's mega-casino standards, but in their time, they filled the bill. The South Tahoe Club sign (seen above) has survived for many years with different names, like "Urgent Care." (Courtesy of John Rauzy.)

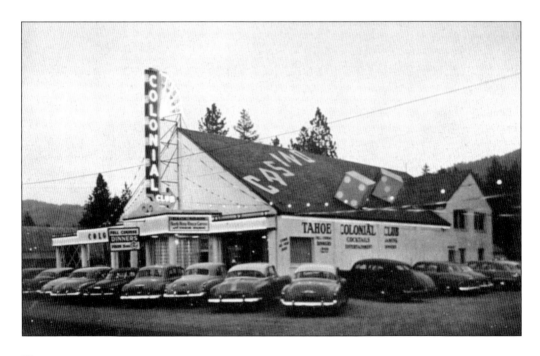

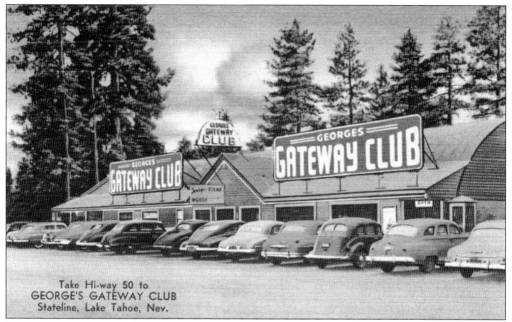

Take Hi-way 50 to
GEORGE'S GATEWAY CLUB
Stateline, Lake Tahoe, Nev.

This card advises the recipient to "Take Hi-way 50 to George's Gateway Club." William F. Harrah purchased this property in 1955 for $500,000. Harvey's Lake Tahoe in now located here.

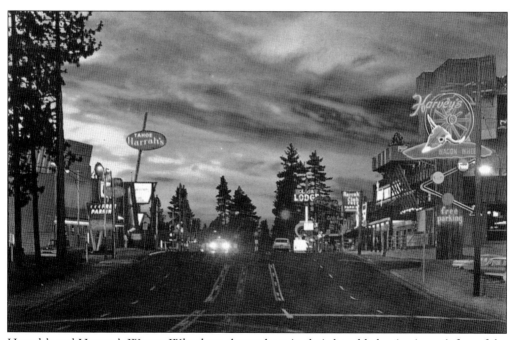

Harrah's and Harvey's Wagon Wheel are shown here in their humble beginnings. A few of the neon signs still exist. The buildings have been replaced by high rises. (Courtesy of Don and Jeanne Davis.)

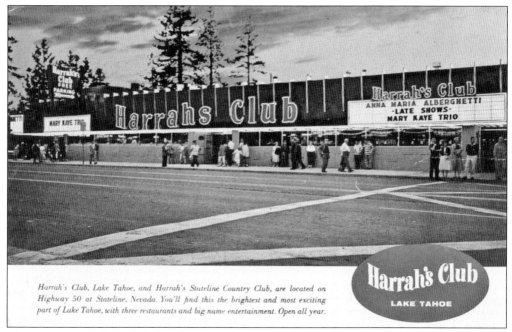

The card reads, "Harrah's Club, Lake Tahoe, and Harrah's Stateline Country Club are located on Highway 50 at Stateline, Nevada. You'll find this the brightest and most exciting part of Lake Tahoe with three restaurants and big-name entertainment. Open all year." (Courtesy of Don and Jeanne Davis.)

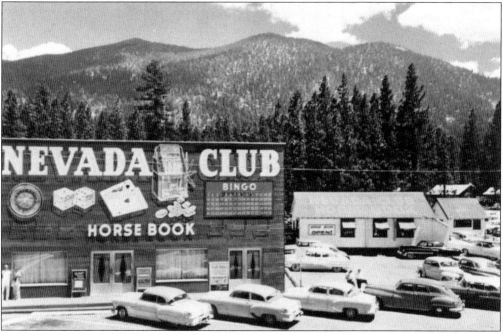

The Nevada Club at Stateline, Nevada, was the first club to pioneer gaming at the south end of Lake Tahoe. It was owned and operated by Clyde Beecher and Bud Beecher. This club was acquired by William F. Harrah in 1958. (Courtesy of Don and Jeanne Davis.)

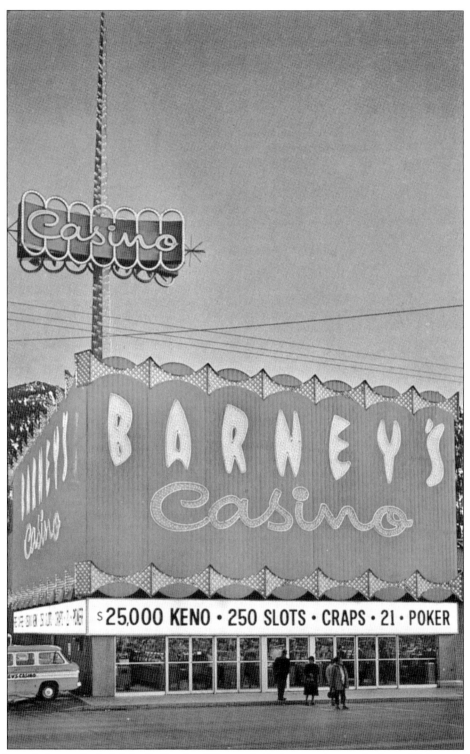

This card shows the brightly lit facade of Barney's Casino on the south shore. This spot later became Bill's Casino, part of the Harrah's holdings.

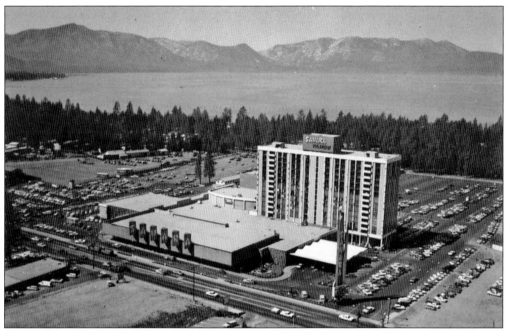

The Sahara was famous for Elvis Presley concerts in the early 1970s. It is now operated as the Horizon, which offers an Elvis suite. The advantage to the guest room towers is that guests can have lake views.

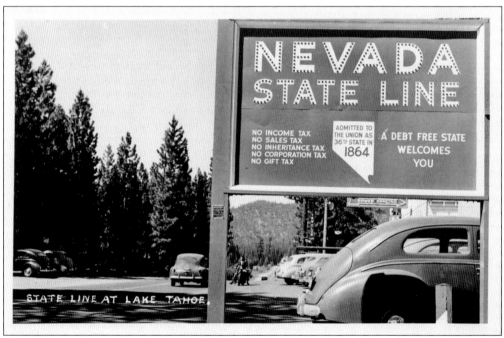

The Nevada state line sign welcomes visitors with promises of no tax. Many residents moved to Nevada for the tax advantages. The downside to lower taxes could be money spent instead on gaming.

Four

GLENBROOK TO INCLINE

Glenbrook was the heart of the logging operations in the basin. Timbers were floated across the lake in booms aided by tugs and steamers such as the *Meteor*. From Glenbrook, wagons pulled the loads up to the top of Spooner Summit, where the load could be transferred to the V-flume, which would take the timber on a 12-mile ride down to Carson City. By 1875, the Carson Tahoe Lumber and Fluming Company had completed a narrow-gauge rail from Glenbrook to the top of Spooner to make transport more efficient. There was a great whirlwind of activity in the basin during the time of the Comstock Lode in Virginia City. By the early 1900s, logging operations had virtually vanished from the basin. Heading north from Glenbrook around the lake, the forests are undeveloped for the most part. There are a few small enclaves, including Skunk Harbor, Secret Harbor, George Whittell's summer place (the Thunderbird Lodge), and a handful of private homes.

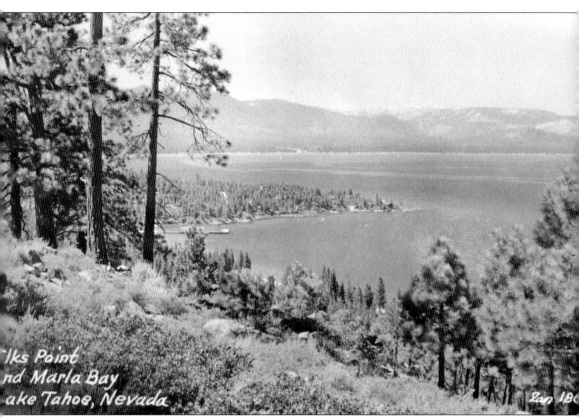

lks Point nd Marla Bay ake Tahoe, Nevada

Marla Bay on Elk's Point was named for rancher John Marley, who raised crops on meadowland. He grew timothy hay and potatoes and other vegetables and sold them to passersby. The Lake Bigler Toll Road gave travelers access to the south shore. Lake Bigler was one of the original names for Lake Tahoe after an early California governor, John Bigler.

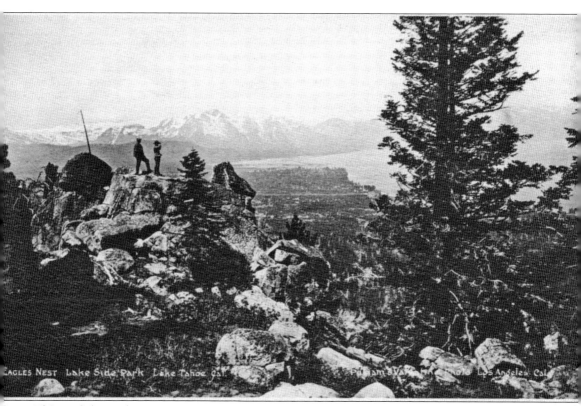

EAGLES NEST Lake Side Park Lake Tahoe Cal. Los Angeles Cal.

This card shows the amazing view at Eagle's Nest, near South Lake Tahoe. This stunning vista shows the topography of the south shore with vast stretches of open, relatively flat land. This offers the residences an easier access to the south shore.

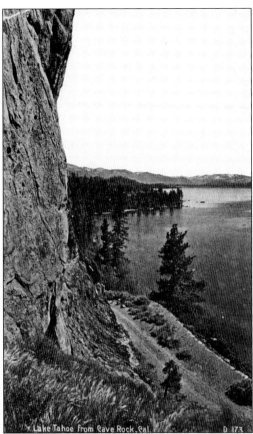

Cave Rock is a landmark discernable from all over the lake and often used by boaters to aid in navigation. The highway once wound around the outside of the rock on a wooden trestle. Decades later, tunnels were constructed through the rock. These are the only highway tunnels that exist around the lake.

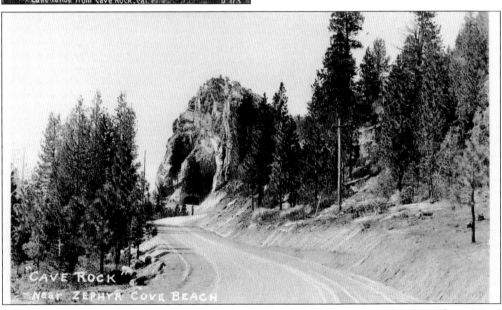

Cave Rock, near Zephyr Cove in Nevada, remains an intriguing spot to this day. The original cave for which it was named has been overshadowed by the tunnels made to accommodate automobile traffic.

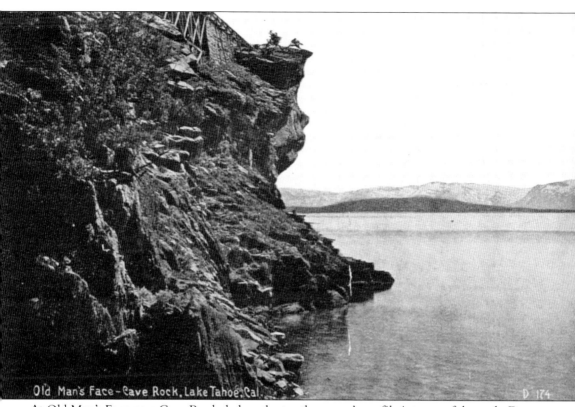

Old Man's Face - Cave Rock, Lake Tahoe, Cal. D 174

At Old Man's Face near Cave Rock, below the trestle, a man's profile juts out of the rock. Due to the rock formations, this spot is popular for fishing. Although, since Tahoe is so vast, many anglers prefer fishing in the streams and alpine lakes.

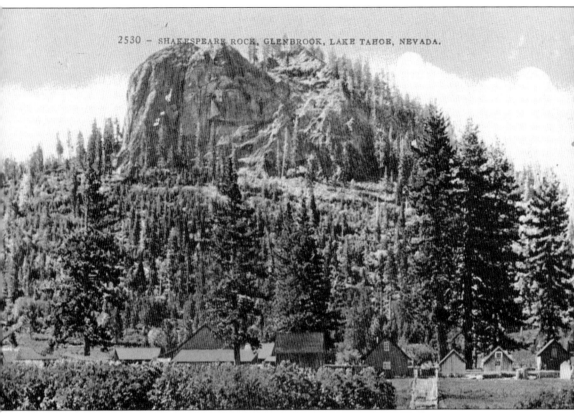

At Shakespeare Rock, near Glenbrook, the rock formation shadowed a collection of cottages. The rock received its name in 1862 from the wife of Rev. J. A. Benton from Massachusetts. While sketching, she noticed that the lichen formation on the face of the rock resembled William Shakespeare.

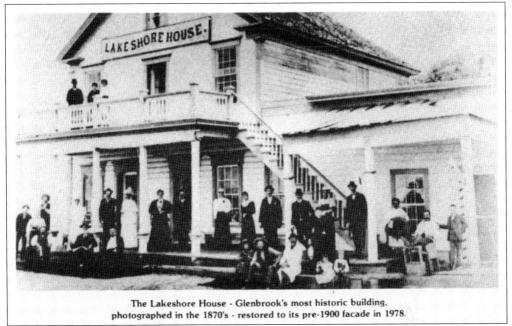

**The Lakeshore House - Glenbrook's most historic building,
photographed in the 1870's - restored to its pre-1900 facade in 1978.**

The Lakeshore House, Glenbrook's most historic building, shown here photographed in the 1870s, was restored to its pre-1900 facade in 1978. The Lakeshore House was built in 1863 by Capt. Augustus W. Pray, one of the first to settle in Glenbrook. It eventually became a wing of the Glenbrook Inn.

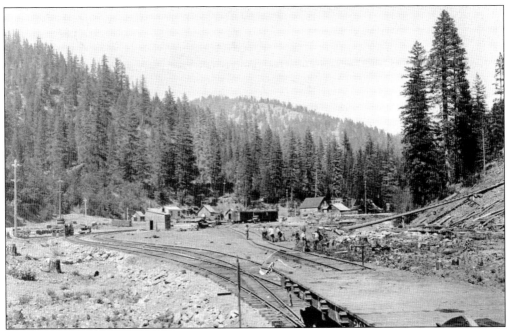

The railyards at Glenbrook were once a busy place. The first sawmill at the lake opened here in 1861. After the Comstock Lode was discovered in 1859, logging demands skyrocketed. Railroads were built to carry redwood and lumber to the mill and later to the top of Spooner Summit.

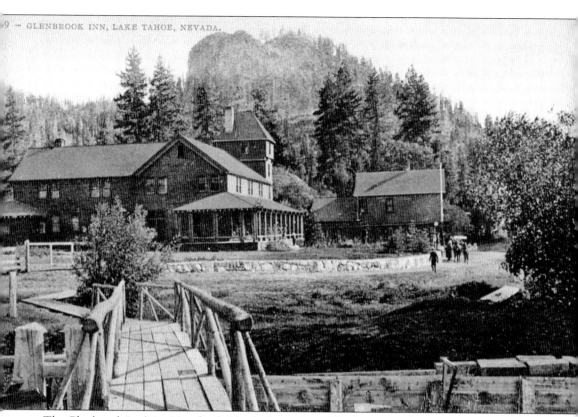

The Glenbrook Inn's inviting footbridge is shown here. The inn opened in 1906 to accommodate the growing tourist influx. It was composed of two former hotels—the Lake Shore House and Jellerson House. In 1875, Glenbrook was visited, on separate occasions, by Gen. W. T. Sherman and Pres. Ulysses S. Grant. In 1879, President Hayes visited Glenbrook.

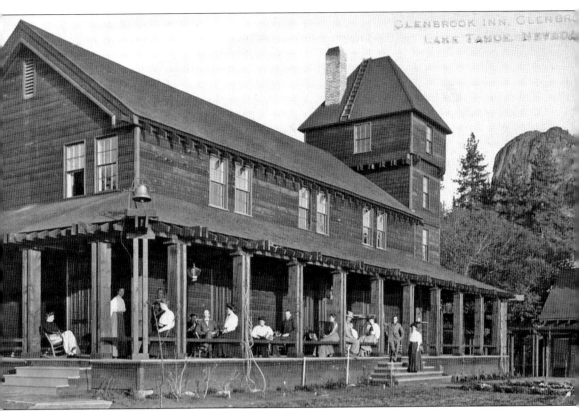

By the time the Glenbrook Inn opened in 1906, logging operations had all but ceased. Visitors would have been astonished to know that over 47,000 acres of timber had been cut, leaving only about 950 acres of timber standing in the basin. During the logging boom, it is estimated that more than 750 million board feet of lumber and 500,000 cords of wood were harvested.

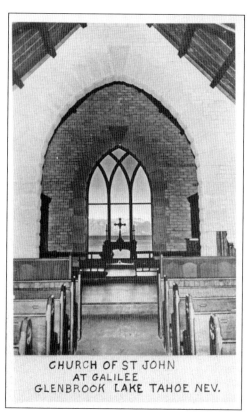

This card of the Church of St. John at Galilee, in Glenbrook, shows the lovely view the parishioners enjoyed.

CHURCH OF ST JOHN
AT GALILEE
GLENBROOK LAKE TAHOE NEV.

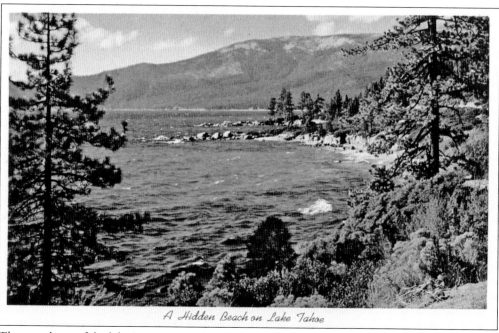

A Hidden Beach on Lake Tahoe

The east shore of the lake is very sparsely populated and not very commercialized; this is thanks to one of the early residents, George Whittell. Whittell owned most of the Nevada shoreline from what is now the Cal Neva south to Zephyr Cove.

SCENIC DRIVE 87
LAKE TAHOE.

After George Whittell's passing, most of this land transferred to the forest service and still remains undeveloped. One of the largest land swaps in USDA Forest Service history included the transfer of Whittell's lakefront Thunderbird Lodge compound, which was swapped for acreage bordering a Del Webb retirement community outside Las Vegas. The lodge is currently operated by the Thunderbird Lodge Preservation Society, which holds a "reservation" on the buildings through the forest service.

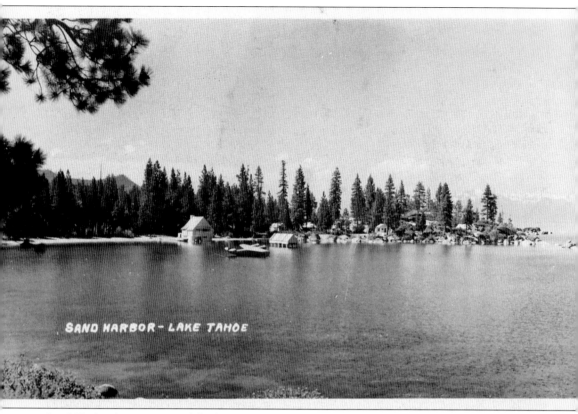

SAND HARBOR - LAKE TAHOE

Sand Harbor boasts some of the best sandy beach on this side of the lake. Once home to one of the Hobart lumber families, later to George Whittell, and then the Fullers, it is now operated as a Nevada State Park.

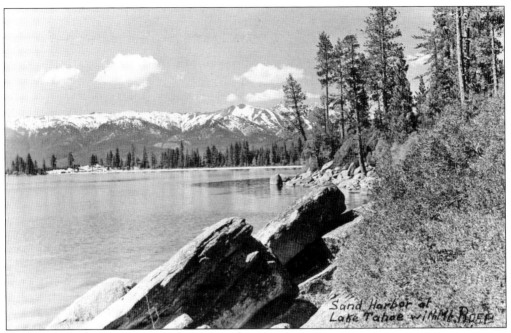

The long stretch of beach in the background is the south side of Sand Harbor.

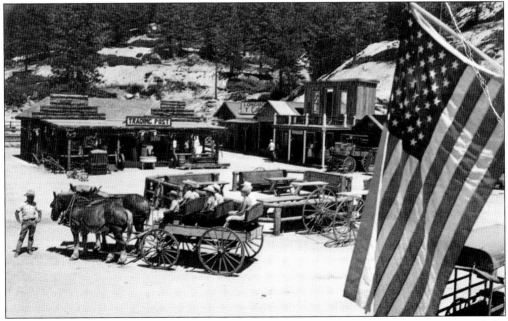

Incline Village may be best known for the famous Ponderosa Ranch where some of the *Bonanza* television series was filmed. This theme park was visited by more than 300,000 guests while it was in operation. There were a variety of attractions for the visitors, such as their breakfast rides, which included a hayride and sumptuous pancake breakfast. (Courtesy of Don and Jeanne Davis.)

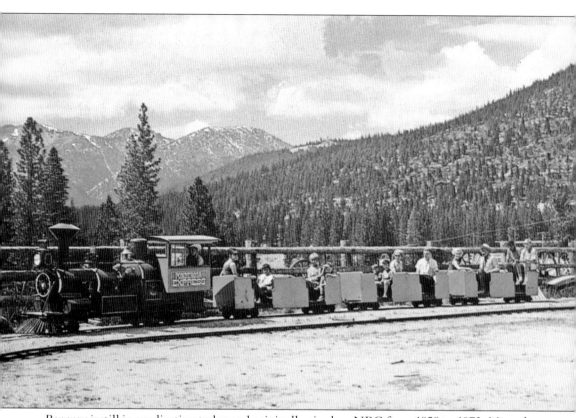

Bonanza is still in syndication today and originally aired on NBC from 1959 to 1973. More than 831 original episodes were aired and broadcast into 86 countries and 12 different languages. (Courtesy of Don and Jeanne Davis.)

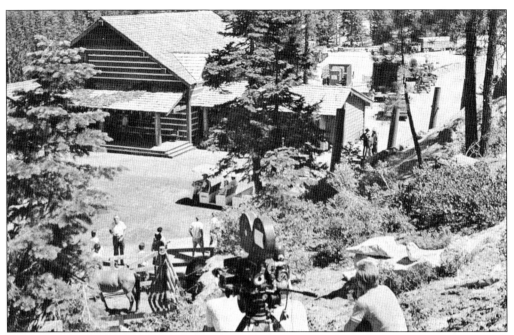

This is Ponderosa's Ranch House. *Bonanza* centered on Ben Cartwright and his three sons. The eldest was Adam, followed by Hoss and the youngest, Little Joe. (Courtesy of Don and Jeanne Davis.)

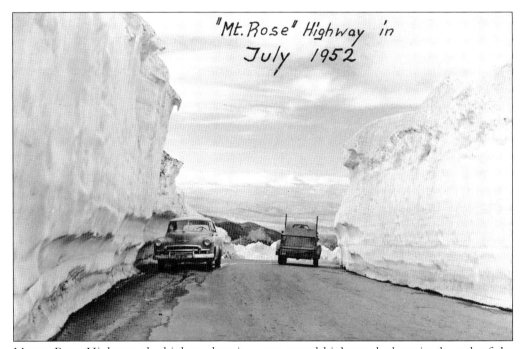

"Mt. Rose" Highway in July 1952

Mount Rose Highway, the highest elevation year-round highway, had retained much of the previous winter's snow in July 1952. This shot was taken after one of the biggest snow seasons at Tahoe.

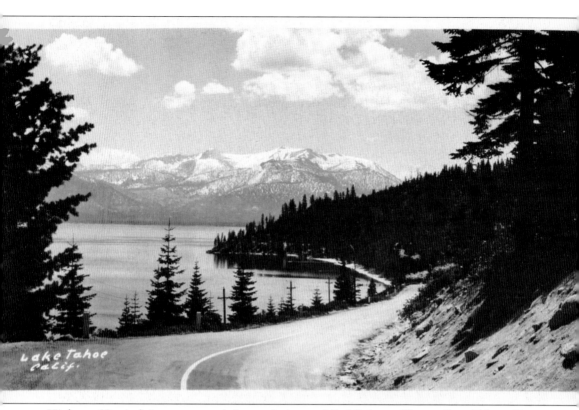

Highway 28 winds its way around the north shore while Highway 89 runs from Tahoe City to the south shore. Highway 50 connects the two.

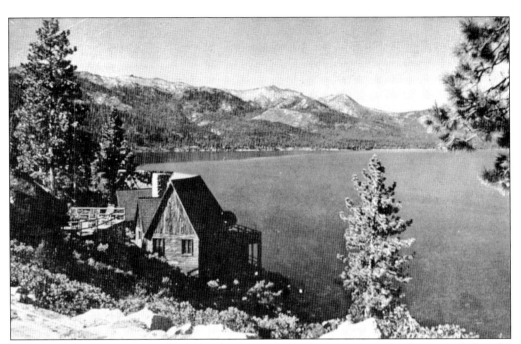

Highways 28 and 89 are two lanes for the most part, and one can imagine how easy it is to be distracted by the beautiful views and the homes clinging to the hillside below.

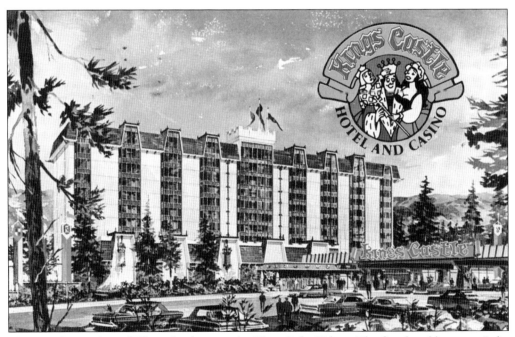

This is a classic view of Kings Castle, now the Hyatt Lake Tahoe. The first hotel here was Lake Tahoe Hotel operated by the Pacific Bridge Association; then it became the Lake Tahoe Hotel and Casino, later the Incline Village Hotel and Casino. Nathan Jacobson acquired the property in 1968 and dubbed it Kings Castle. It again changed hands in 1973 until it was eventually purchased by the Hyatt in 1975.

"Having a wonderful vacation," reads the back of this Tahoe panorama card sent in 1959. "Lots of rest, sun and water skiing. Will be home a week from Saturday. Father Jim."

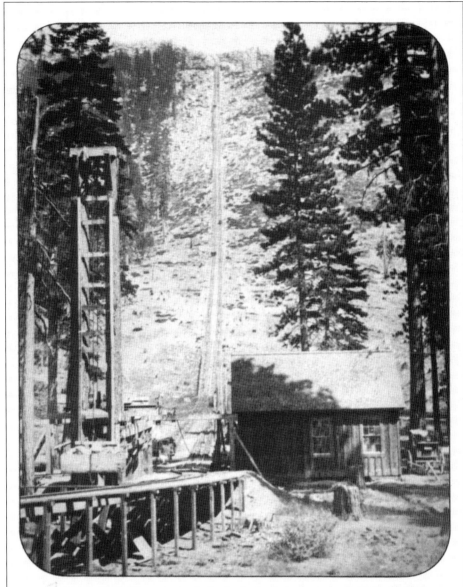

✿ THE GREAT INCLINE TRAMWAY ✿

LIFT 1,400 FT.
LENGTH: 4,000 FT.
CABLE: 1" DIAMETER
PULLEY: 12" DIAMETER BULL WHEEL
PRINCIPLES: W. S. HOBART,
S. H. MARLETTE & A. HAYWARD

POWER: 40 H.P. STEAM ENGINE
OPERATION DATES: 1880 TO 1894
LOCATION: INCLINE VILLAGE, NEVADA
OWNERS: SIERRA NEVADA WOOD &
LUMBER COMPANY

The Great Incline Tramway was a feat of engineering in its time. The tramway was an integral part of the lumber operations in Incline. As in Glenbrook, timbers could be hauled to the top of the peak and sent down the other side. (Courtesy of Don and Jeanne Davis and Nevada Historical Society.)

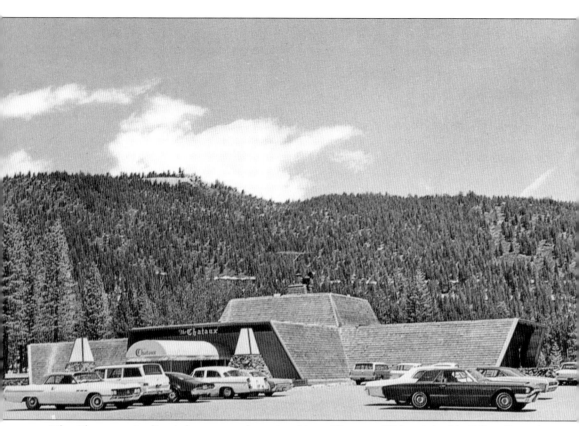

The Chateau at Incline is home to a championship golf course. This original building from the early 1960s was torn down in 2004 to make room for the new building, a $9-million structure. The Chateau serves as a multifunctional meeting center, special event facility, and community meeting place managed by the Incline Village General Improvement District.

Five

CRYSTAL BAY TO CARNELIAN BAY

The state line at the north end of the lake falls at Crystal Bay. The famed Cal Neva Resort resides on both sides of the state line. It is best-known for the days when Wingy Grober and Frank Sinatra operated the lodge. The Celebrity Room headliners included Marilyn Monroe, Juliette Prowse, Mickey Rooney, Louis Prima, Keeley Smith, Ella Fitzgerald, and, of course, members of the Rat Pack. The casinos at Crystal Bay have changed hands a number of times over the years, and some have faded from the landscape entirely. Heading west through Kings Beach and Tahoe Vista, the reader will reach the final destination of Carnelian Bay.

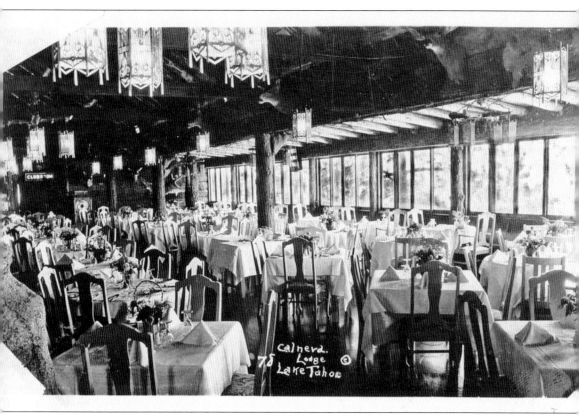

Pictured is the Cal Neva Lodge's grand dining room with its spectacular lake views. The Cal Neva Lodge burned to the ground in 1937 and was rebuilt in 30 days by Tahoe developers Norman Biltz and Adler Larsen. They employed 500 men to work around the clock.

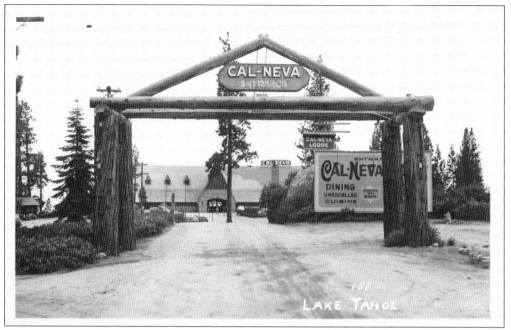

The entrance to the Cal Neva is seen here. Though the buildings have remained virtually the same, the entrance has undergone a number of face-lifts. This rustic arch guards the elegance of the grand interior of the lodge.

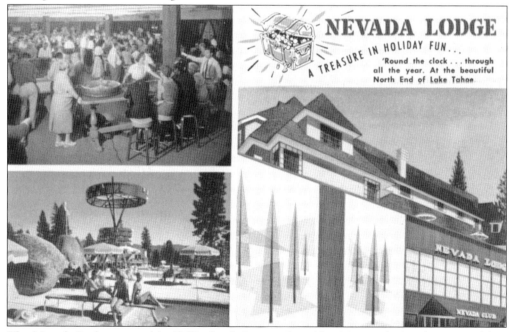

The Nevada Lodge opened in 1958 after being purchased by Meta and Lincoln Fitzgerald. It was built as the Tahoe Biltmore in 1946 by Joseph Blumfeld. Subsequently it was purchased in 1952 by Eddie Hopple, Jacki Gonn, and David Crow. The casino again changed hands in 1985, when it was purchased by Tahoe Crystal Bay, Inc., and changed its name back to Tahoe Biltmore in 1986.

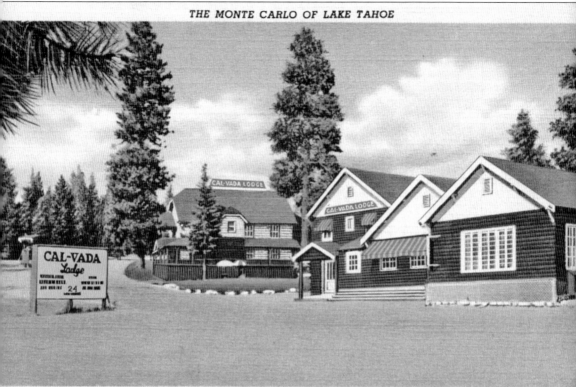

CAL-VADA LODGE CRYSTAL BAY, NEVADA

"Cal-Vada Lodge—the Monte Carlo of Lake Tahoe" was owned by Joby Lewis. It was also later known as the Bal Taberin. This name was chosen as it was also the name of a nightclub in San Francisco owned by Tom Guerin, one of the partners. Headliners such as Lena Horne, Nat "King" Cole, and Tony Martin appeared. It was later purchased by the Fitzgeralds, who ran the Nevada Lodge.

The Tahoe Biltmore is seen here much as it looks today. Crystal Bay may have been named for George Crystal, a lumberman from Douglas County who filed with the U.S. Land Office for timber sections on this part of the bay. This photograph is from the early 1950s.

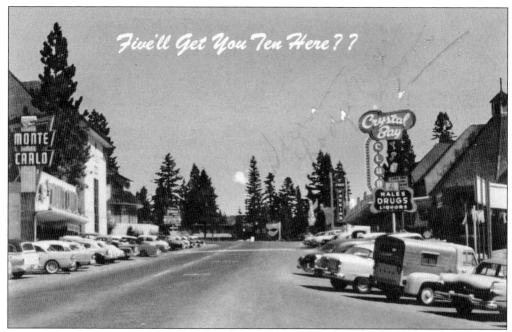

The Monte Carlo, seen on the left, is situated at the west end of the Tahoe Biltmore building and was owned by Joby Lewis. The Crystal Bay Club, seen on the right, was first established as the Ta-Neva-Ho by Johnny Rayburn, a longtime north shore local. The original club housed a casino, restaurant, post office, drugstore, dress shop, dance studio, and at one time a Wells Fargo branch. The bowling alley was later a ballroom.

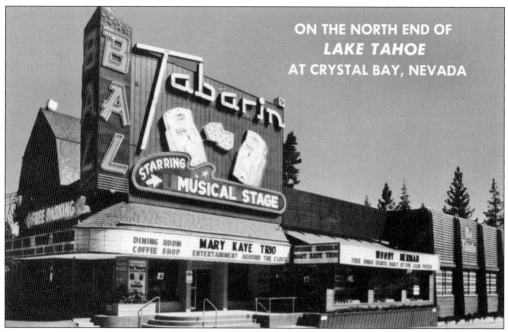

The Bal Tabarin casino was on the north end of Lake Tahoe at Crystal Bay, Nevada. Like its namesake in San Francisco, the Bal Tabarin hosted many celebrity entertainers.

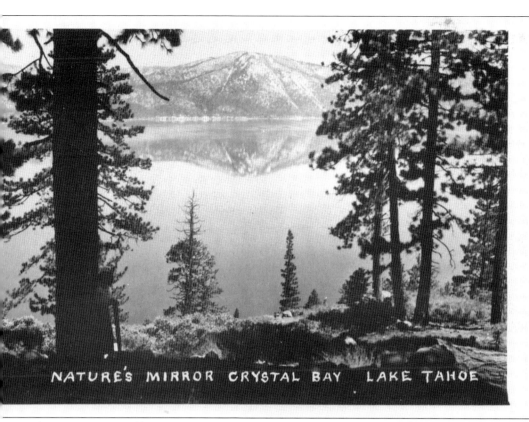

NATURE'S MIRROR CRYSTAL BAY LAKE TAHOE

The name says it all: Nature's Mirror Crystal Bay. A refreshing change from the gaming experience is a glance at the lake. On windless days, it appears smooth as a piece of glass, reflecting the mountains above.

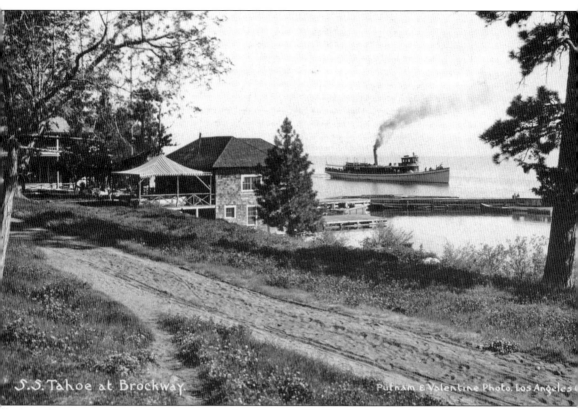

S.S. Tahoe at Brockway.

Putnam & Valentine Photo, Los Angeles

Brockway Hot Springs was opened as Campbell's Hot Springs in 1869. Billy Campbell and George Schaeffer privately began construction of a road from Truckee that would deliver guests to the hostelry. The original structures included a square bathing house over the mineral spring at the water's edge.

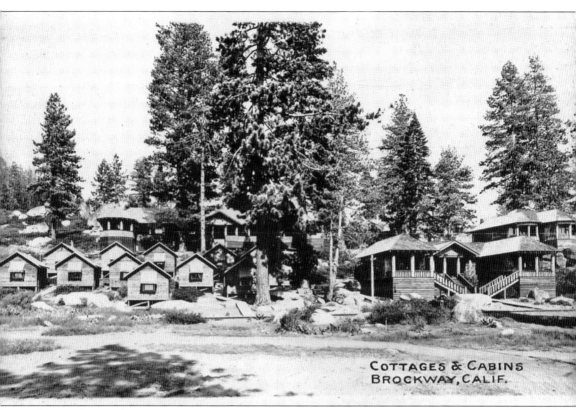

COTTAGES & CABINS
BROCKWAY, CALIF.

The Brockway cabins are seen here. By 1874, there was a road leading from Tahoe City, enabling Billy Campbell to extend his stage line and entice more guests. By 1883, the resort was leased to A. A. Bayley and renamed Carnelian Hot Sulphur Springs, which was rather confusing as Carnelian Bay is located to the west. In 1899, it changed hands again. It was purchased by Frank Brockway Alverson and his wife, Nellie. They renamed it Brockway Hot Springs.

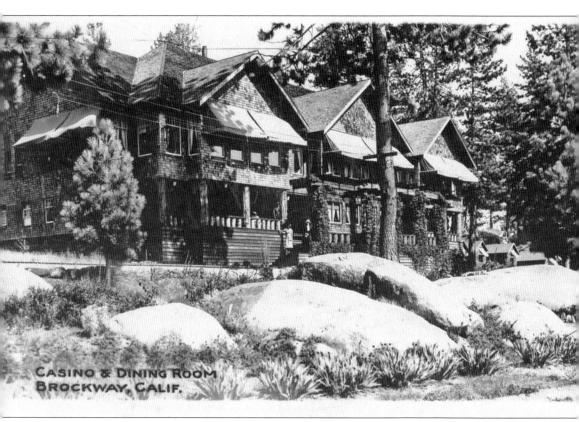

CASINO & DINING ROOM
BROCKWAY, CALIF.

Here is the Brockway casino and dining room. The Alversons implemented many upgrades, including piping the hot spring water to the guest rooms. They still found it difficult to make ends meet and sold out to Lawrence and Comstock (of Tallac Hotel on the south shore) in 1909. The buildings in this photograph were added in 1917.

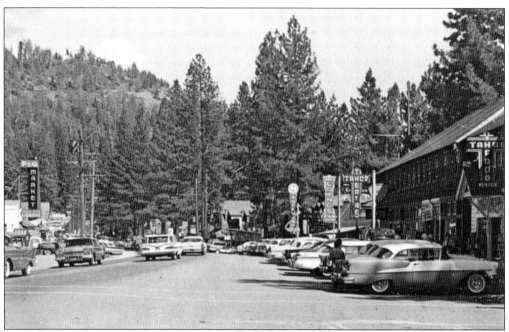

Kings Beach was settled in 1925 by Joe King. He developed it into a bustling town of motels, theaters, markets, stores, cafés, and homes. A legend exists that King won the land in a poker game with George Whittell or Robert Sherman. It could not have been from Whittell as his holdings were on the Nevada side, so it is more likely that he acquired the property from Sherman.

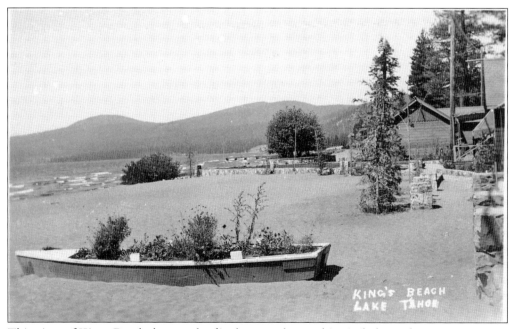

This view of Kings Beach shows a derelict boat used as a whimsical planter box.

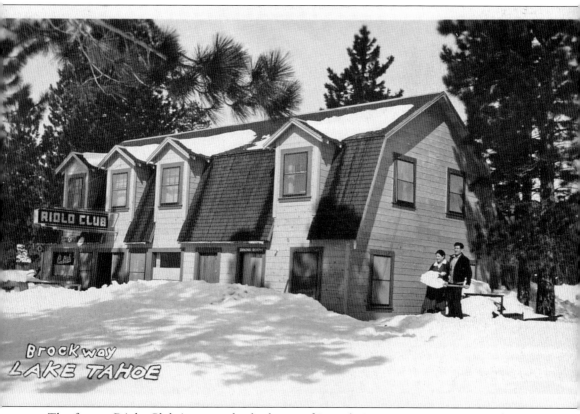

The former Riolo Club is currently the home of Lanza's Restaurant in Kings Beach. Many businesses find it difficult to operate at Tahoe due to the slow seasons between summer and the first snow and between ski area closures and summer. Lanza's has beaten the odds and continues to operate a successful venture.

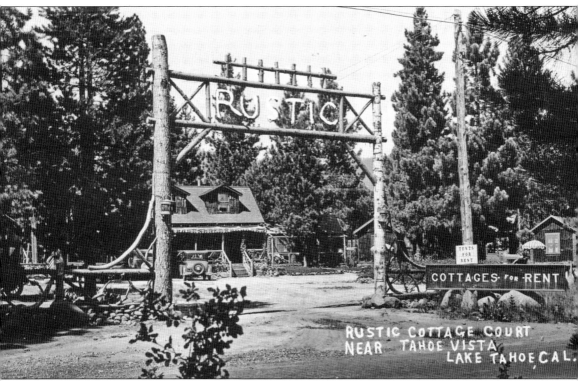

The Rustic Cottage Court is one of the few places in Kings Beach that has stood the test of time. These "funky little shacks," as noted on hotel correspondence, still offer comfortable accommodations. Tahoe Vista was originally settled in 1865 as Pine Grove Station. It became a landing spot for saw logs chuted down from the Martis Peak area and the headwaters of Griff Creek.

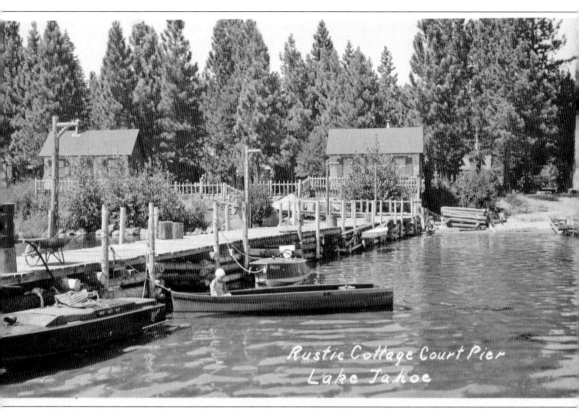

Rustic Cottage Court Pier
Lake Tahoe

The Rustic Cottage Court pier is shown here with stylish wooden speedboats. This section is now privately owned, but one can imagine renting a bungalow right on the beach at the height of the summer season. Just down the beach, the Tahoe Vista Hotel and Casino were built. By 1913, the Tahoe Vista Casino was built extending out over the lake.

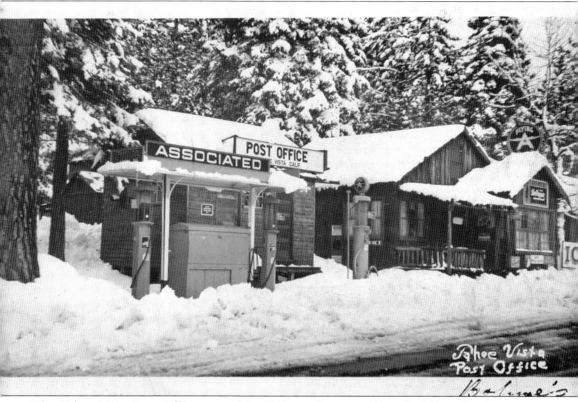

The Tahoe Vista Post Office opened in 1911, at the same time the Tahoe Development Company was selling lots in Tahoe Vista and the Tahoe Vista Hotel was in full swing. In the winter of 1922–1923, the hotel burned down and operations centered in the casino.

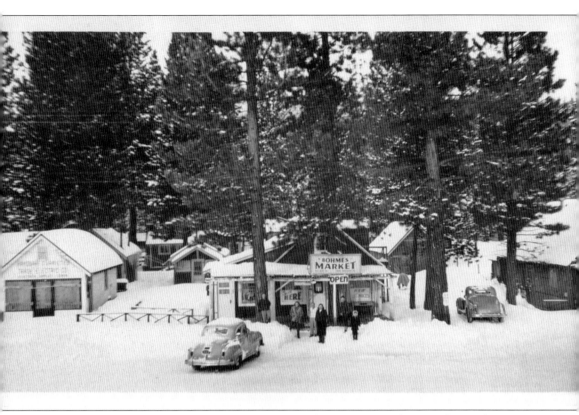

Adjacent to Tahoe Vista is Agate Bay, known in the 1860s as Little Cornelian, where miners found stone to use for their fireplaces and foundations. It was also known as Bay City, where lumbering equipment was brought from Hobart's Mill in Incline and then hauled over the hill. Residential development began in the 1930s.

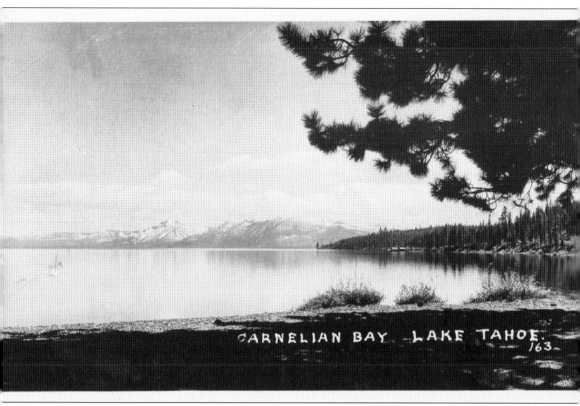

Postmarked August 38, 1939, at Homewood, this card reads, "Dear Mother, Will plese give me Bobby B address. Your son, Raymond." This sweeping view of Carnelian Bay portrays the mirror-like quality of the lake.

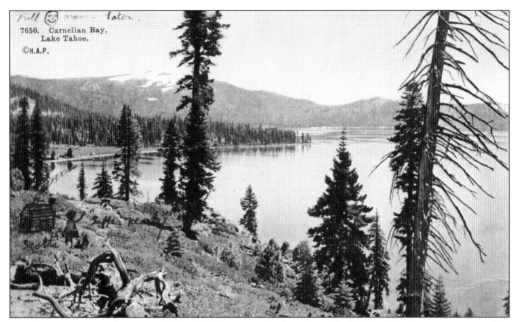

In 1871, Dr. Bourne's Hygenic Establishment, a rival to Campbell's Hot Springs, was opened at Carnelian Bay. The name changed in 1873 to Cornelian Springs Sanitoria. Dr. Bourne lived at the bay year-round and in winter had no neighbors for miles. By 1896, the Flick brothers had acquired most of the Carnelian Bay waterfront.

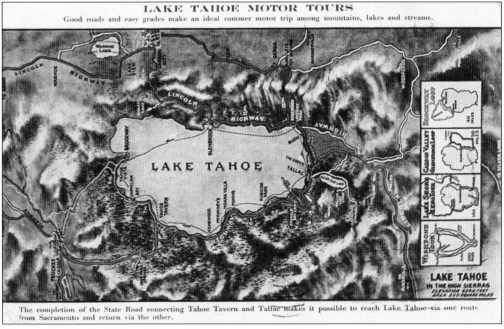

This card of Lake Tahoe Motor Tours shows the different highways around the lake and surrounding areas. The card is postmarked July 17, 1920, and reads, "Zella dear—Just to tell you that I am having a wonderful rest and am almost over waking in the wee small hours to hare my wee daughter's wee voice. Was glad to hear you are getting along nicely. Love to Lenny, from Dot."

Six

LAKE OF THE SKY

The Washoe have been coming to the lake for as long as they can remember. The name Tahoe was derived from the Washoe word for the lake, which is *Da-ow-a-ga*. The meanings vary from "edge of the lake" to "big water." The Washoe people came to the lake each spring to hunt, fish, and gather provisions. Each family group had a special place they would stay at each season, just as people come to their summer homes today. Da-ow was known as the giver of life and center of the Washoe world. In the fall, the Washoe moved on to the Pine Nut Hills to collect one of their most important foods, the pine nut. The lake has a profound effect on many who visit. This chapter will provide more of the letters that were written on the flip side of the postcard image. Countless cards refer to the lake as beautiful and many talk about the weather.

Treasured memories have been made here for generations. Perhaps it is a special place because people come here to relax, unwind from the rigors of their daily lives, and enjoy the clean air and the beautiful scenery.

Greetings from Lake Tahoe! The back of this card reads, "Dear family—Just got home from a 15 mile bicycle ride. The weather has been ideal. Art has a sunburn and I'm getting tan. We expect to stay here about 1 week and 3 days and then may go to Oakland for a day or two. Love Birdie and Art."

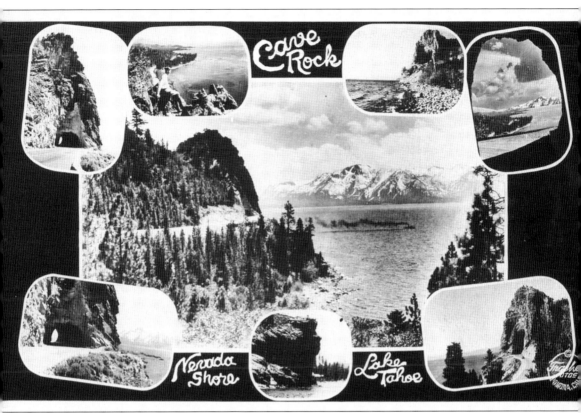

The back of this card reads, "Dear folks we are now located at Bill Johnsons place at Homewood and will be here a week. Better come up. Have a big tent so bring the bed and come on. The other place was beautiful but not very desirable. We stopped in Reno overnight and gambled a bit. It is some sight. Come up and we'll take you over there. We want to go back for a day. We've traveled over 300 miles over most beautiful country. Wish you had been with us—Love Bill and Jeanne."

7655. THE CHAPEL OF THE TRANSFIGURATION IN THE WOODS NEAR TAHOE TAVERN — CAL.

This chapel still stands about a mile south of Tahoe City. The back of the card reads, "Dear Pappy, We have a cabin at Meek's Bay and doing all right for ourselves. So you got to Silver Lake! Hope you had a nice time. We camped out in a meadow last nite and slept under the stars. More fun! We plan on leaving Fri. morn and arriving back by Silver L. Hope all is well with you and Billy—Love to both of you, Ruth."

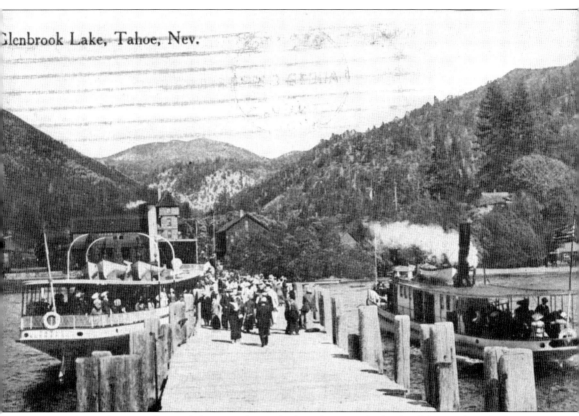

Glenbrook Lake, Tahoe, Nev.

Pictured are the SS *Tahoe* and the *Nevada* at Glenbrook pier. The back of the card reads, "Dear Niece and Henry: We rec'd your letter glad to hear from you. Sorry H has to go to the Dr. but it's best to have a check up once in a while. We are here yet, I had not been so well and had to go to the Dr in Carson City and he has helped me I feel much better—artrie trouble. I will go Monday again. Friday we'll leave for Sac. It is cold mornings, days are fine down to 24 degrees some mornings but we keep nice and warm. If you write same address as last place. As ever, Virginia and Bill."

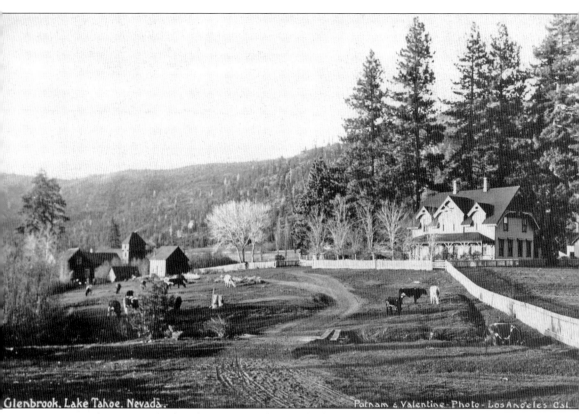

Glenbrook. Lake Tahoe. Nevada. Putnam & Valentine-Photo- LosAngeles. Cal.

A pastoral scene at Glenbrook is depicted here. The back of the card reads, "Dear Warren, it is a good thing that I didn't have you write until I let you know my address. We are domiciled at Colfax. Imagine the heat, it takes energy to think. I wish that we might have remained at Tahoe a while longer, Love Sis Write me at Colfax."

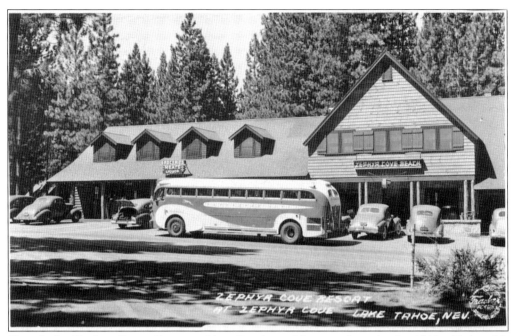

Here is the Zephyr Cover Resort with a Greyhound bus out front in the 1940s. Today this resort is operated under permit of the USDA Forest Service. (Frasher Fotos.)

On the pier at Tallac, in the days of Prohibition, liquor bottles were thrown into the lake to remove any trace of wrongdoing. Hundreds of bottles are said to litter the bottom of the lake in this location. The back of this card reads, "This Postal shows a very tough cow puncher but if I can recollect well he is sure a Boy and good friend of mine. Julius."

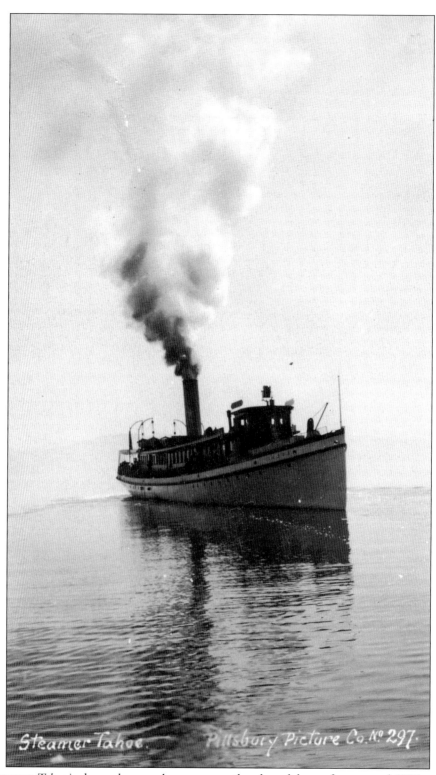

The steamer *Tahoe* is shown here under power on the glassy lake surface around 1925.

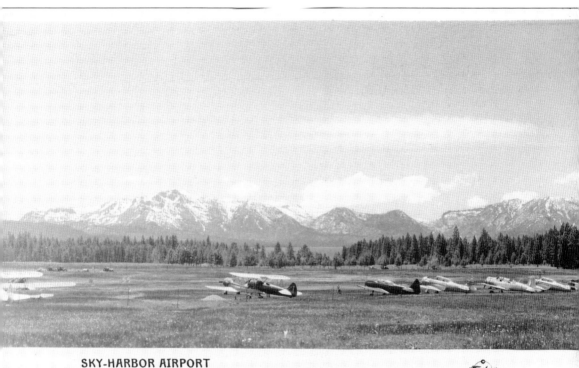

SKY-HARBOR AIRPORT

on the Nevada shore of

BEAUTIFUL LAKE TAHOE

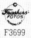

F3699

Sky-Harbor Airport, near South Lake Tahoe, Nevada, was the first airstrip to border Lake Tahoe. It was near Tahoe Village, a modern hotel and gaming casino adjoining Highway 50 above the airfield. Prior to the airport's construction, this area was known as the settlement of Hobart, named after Walter Hobart. Hobart struck it rich on the Comstock, became a millionaire by age 21, and then purchased this section of meadowland, used for lumbering, ranching, and ranging dairy cattle in the summertime. (Frasher Fotos.)

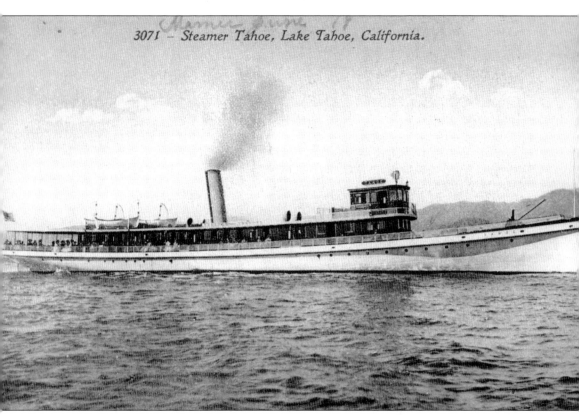

3071 – Steamer Tahoe, Lake Tahoe, California.

The sturdy steamer *Tahoe* was designed by Union Iron Works in San Francisco. It was transported in pieces by train to Lake Tahoe, where it was assembled at Glenbrook and launched in 1896. The steamer is still a piece of Tahoe nostalgia and rests on the bottom of the lake after an intentional lake burial by its owners, the Bliss family, in 1940. The scuttling of the steamer *Tahoe* also prevented the craft from being converted into scrap metal needed for the efforts of World War II. The back of this card, postmarked 1909, reads "Friday morning June 19—Dear Folks. Trying to rain; bad day for the outdoor exercises. The S.P. picnic is the 27th a week from tomorrow. I doubt there will be any outdoor exercises—raining now. Fleming had a big tooth pulled the other day and will have to have another pulled today. Your loving daughter Mamie."

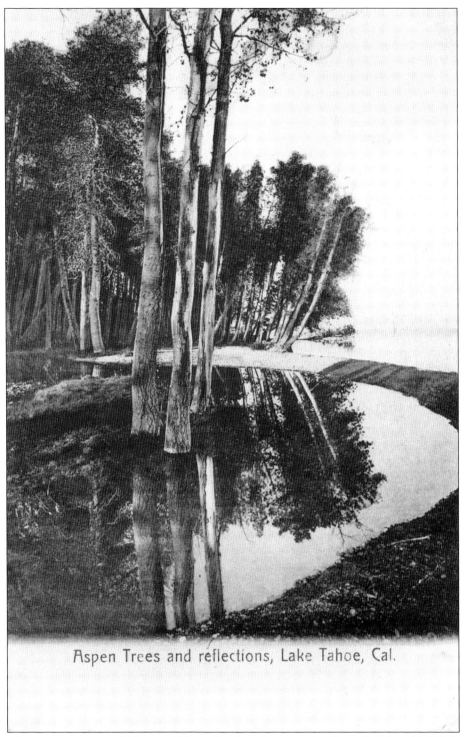

Aspen Trees and reflections, Lake Tahoe, Cal.

The picturesque aspen at Tahoe proliferate in elevations ranging from 5,000 to 10,000 feet in the Sierra, where they inhabit swampy meadows, gravelly slopes, and the base of lava jumbles. The back of this postcard dated July 20, 1909, reads, "Dear Mama: Got here alright on half-ticket. The conductor never said a word. Martha."

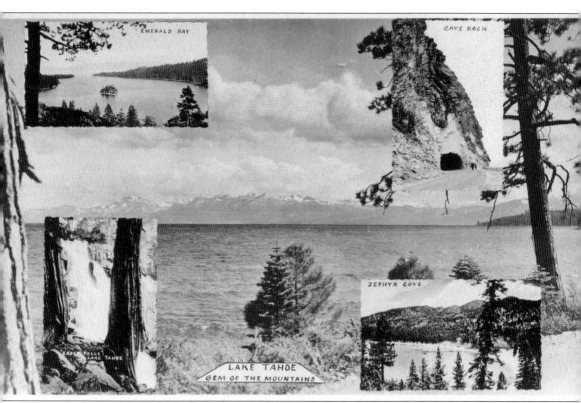

This postcard, touting "Lake Tahoe Gem of the Mountains," highlights four of the most visited and scenic spots on the lake: Emerald Bay, Eagle Falls, Zephyr Cove, and Cave Rock. These points of interest all have historic significance. Emerald Bay (once known as Eagle Bay) was the former location of Kirby's Emerald Bay Resort. It is the current location of Vikingsholm Castle and accompanying tea house on Fannette Island. Eagle Falls is situated high above Emerald Bay. The falls originate from Eagle Creek and Lake. The back of this postcard reads, "Dear Tillie—Well, kiddo how are you? Hope everything goes alright. We are all feeling fine and having a good time breaking camp this noon again. I have had a wonderful trip. Will write from Berkeley next week. Hello to Alice. Love Mother."

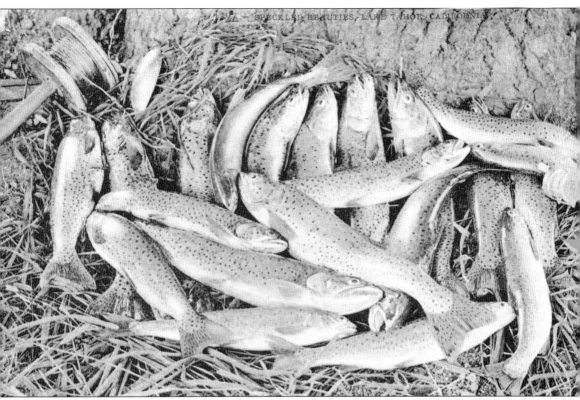

The caption on this card reads, "Speckled Beauties, Lake Tahoe, California." Albert and Bertha Nelson of Paso Robles, California, fished the summers at Lake Tahoe and became friends of the early fisherman. In 1909, they slept under the pine trees. The following summer, they occupied a deserted cabin. They both fished for the market for three summer months each year. If the trout weighed just under a pound, a pebble or two was put in their throat to meet the market weight of one pound. The back of this card, dated June 27, 1909, reads, "Here are a sample of the fish we are fishing day after day for. Just about a day's catch. We are getting from 25 to 40 cents a pound for them. Not to forget the happy and agreeable partner made about $120.00 the first month."

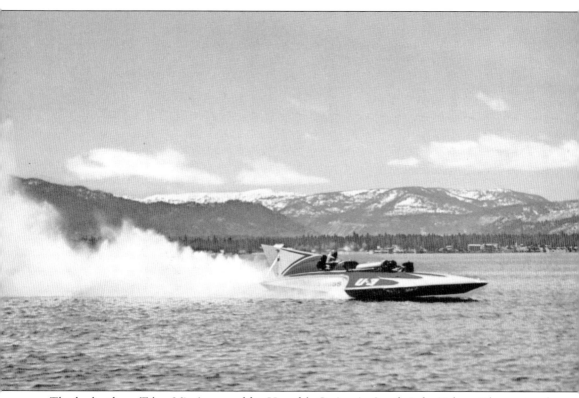

The hydroplane *Tahoe Miss* is owned by Harrah's Casino in South Lake Tahoe. The postcard caption reads, "Against a backdrop of the snowcapped Sierra, Harrah's 'Tahoe Miss' churns a rooster-tail of spray on Lake Tahoe." Harrah's Tahoe Championship Regatta was an annual fall event featuring unlimited hydroplanes. The event took place at the lake's beautiful south shore, where one could observe these "rooster-tailers" roaring and careening around the lake at speeds exceeding 85 miles per hour. These events became so competitive in the mid-1920s that on race day mornings, one could expect frequent reports of sabotage, including mysteriously opened sea-cocks, steel grindings found in the carburetor intakes, and other below-the-belt strategies to win.

BIBLIOGRAPHY

Givens, Stefanie A., and Sara K. Larson. *Woven Legacy: A Collection of Dat-so-la-lee Works, 1900–1921.* Reno, NV: North Lake Tahoe Historical Society, 2005.

Goin, Peter. *Lake Tahoe.* Charleston, SC: Arcadia Publishing, 2005.

Lekisch, Barbara. *Tahoe Place Names: The Origin and History of Names in the Lake Tahoe Basin.* Lafayette, CA: Great West Books, 1996.

Scott, E. B. *The Saga of Lake Tahoe, Volume I.* Carmel, CA: Sierra-Tahoe Publishing Company, 2000.

———. *The Saga of Lake Tahoe, Volume II.* Carmel, CA: Sierra-Tahoe Publishing Company, 2002.

Van Etten, Carol. *Tahoe City Yesterdays.* Tahoe City, CA: Sierra Maritime Publications, 1987.

Wheeler, Sessions S. with William W. Bliss. *Tahoe Heritage: The Bliss Family of Glenbrook, Nevada.* Reno, NV: University of Nevada Press, 1992.

Across America, People are Discovering Something Wonderful. *Their Heritage.*

Arcadia Publishing is the leading local history publisher in the United States. With more than 4,000 titles in print and hundreds of new titles released every year, Arcadia has extensive specialized experience chronicling the history of communities and celebrating America's hidden stories, bringing to life the people, places, and events from the past. To discover the history of other communities across the nation, please visit:

www.arcadiapublishing.com

Customized search tools allow you to find regional history books about the town where you grew up, the cities where your friends and family live, the town where your parents met, or even that retirement spot you've been dreaming about.